The Drawing Breakthrough Book

A Shortcut to Artistic Excellence

John Hastings

Draw 3 Lines Publishing
P.O. Box 1522
Hillsboro, OR 97123-3954
www.Draw3Lines.com
503-648-9905

ISBN (paperback): 978-0-9749418-2-0

Library of Congress Control Number: 2007902073

Printed and bound in the United States of America.

Publisher's Cataloging-in-Publication
(Provided by Quality Books, Inc.)

Hastings, John, 1950-
 The drawing breakthrough book : a shortcut to
artistic excellence / John Hastings.
 p. cm.
 Includes bibliographical references and index.
 LCCN 2007902073
 ISBN-13: 978-0-9749418-2-0
 ISBN-10: 0-9749418-2-4

 1. Drawing--Study and teaching. I. Title.

 NC650.H37 2007 741
 QBI07-600093

Contents

About the Author

In 1998, frustrated with the drawing lessons he was taking, John Hastings began simplifying the process of learning to draw. He was also motivated by the belief that there was a missing link in the usual approach. Influenced by the writings of positive-reinforcement trainer Karen Pryor, Hastings became fascinated with the idea of breaking drawing skills into small parts. In *The Drawing Breakthrough Book,* he combines years of research and experimentation with his passion for drawing to create a unique system for learning to draw.

Hastings has had a lifelong interest in learning new skills. He has earned a bachelor's degree in liberal arts, an associate degree in electronics, and a certificate in technical communications. While he's been an electronics technician for more than 20 years, he's also been a tennis instructor, a guitar instructor, and a ballroom dancing teacher's assistant.

Getting the Most from This Book

No matter how well you now draw, you can advance your skills with *The Drawing Breakthrough Book*. To get the most from it, you need to go beyond merely understanding its contents. The exercises will help you to practice and then master what you learn.

Once you finish the last exercise of chapter 1, repeat the exercise regularly as you read through the rest of the book. Use whatever paper is available, even sticky notes. That way, when it's not convenient to set up objects for still-life drawings, you're still able to practice.

The drawing system you're about to learn isn't meant to be followed rigidly. Feel free to adapt or ignore parts based on the results of your own drawing experiments. Discover the joy that can be found in the moment – when you're drawing just for the sake of drawing – without concern for special techniques or what the finished product will look like.

If you have questions about the instructions or have suggestions on how I can improve them in future editions, please write to me at the address on the copyright page. I'd be delighted to hear from you.

John Hastings

Setting Up Your Drawing Surface

You can draw on any sturdy table, but you'll have more control if you add a board that's raised at the back. (Your posture improves, too.) You can also use a table easel or a full-sized easel. An easel works well for still-life drawing because it puts the subject closer to your line of sight.

When you're drawing objects, you can view them better by placing them on top of a box. You might want to have a few boxes to choose from so that you can place the group of objects higher or lower. Some objects will look very different when you change your viewing angle.

Placing Your Lighting

You'll find drawing more enjoyable when you make sure that both your subject and your paper are well lit. When you draw, shine a bright light over your left shoulder. If you're left-handed, shine it over your right shoulder.

> **TIP:** Don't let these details get in your way. When you don't have just the right drawing equipment, make do with what you have. For example, you can fasten paper to a drawing board, prop it on your lap (and maybe against a table), and draw whatever's before you.

Limiting Your Sessions

To maintain your concentration, limit your drawing sessions to 30–60 minutes. If you draw for longer periods, remember to take occasional breaks.

> **Steady Practice Makes Progress**
> For faster progress, practice in short sessions several times a week rather than in long sessions less often.

Choosing Drawing Tools

For the exercises, I recommend a soft B or 2B pencil and a pencil sharpener. When it's all that you have on hand, use another type of pencil or a pen.

For erasers, I recommend a kneadable eraser or a white hard eraser. A kneadable eraser offers three advantages: you can mold it into any shape, fold it over itself to produce a clean surface, and use it without leaving particles on your paper. A white hard eraser removes pencil marks more completely. Brush away eraser particles with a dry, bushy, soft brush.

Choosing Tape and Drawing Paper

Learning to draw lines in all directions is easier if you're not tempted to turn your paper. Secure the paper on your drawing surface with removable tape.

Using a large sheet of paper, 11" x 14" or larger, will encourage you to make larger motions with your arm. Smaller-sized paper is all you need for the exercises in chapter 1. Higher-quality paper gives you better-looking drawings. When you start to practice drawing triangles, squares, circles, and ellipses, scrap paper is fine.

Using Other Methods

This book helps you dramatically improve your ability to draw with lines, but there are many other important aspects to drawing. In addition to using this book, explore more ways to learn how to draw. Consider taking classes, using kits and other books, and drawing from your imagination.

"The essence of drawing is the line exploring space."

– Andy Goldsworthy

Part One
Starting to Draw

This book teaches you how to draw progressively more challenging subjects using just lines. You'll learn to observe, visualize, and then draw lines with confidence. You'll be able to apply your new skills whenever you draw. In part 1, you will get your bearings and learn how to make drawing with lines more manageable.

Chapters 1 and 2 contain ideas that you can use at many different stages of a drawing. Chapter 3 covers methods for organizing the drawing process.

10 Reasons to Learn to Draw

✎ Express your emotions.

✎ Think with a pencil and sketch your ideas.

✎ Develop a foundation for painting or sculpting.

✎ Study more effectively by adding visual notes.

✎ Illustrate a journal or a daily planner.

✎ Make simple maps.

✎ Record a special moment.

✎ Give captivating presentations.

✎ Create unique works of art as gifts.

✎ Decorate your living or office space.

✎ And one more: Have fun!

1
The Magic of Seeing Lines and Shapes

Drawing is a complex act. It relies on your ability to observe lines and shapes on your subject and to then imagine them on paper. Luckily, when you draw, most observations involve the same basic trick or technique: comparing one thing to another. You need to compare the parts of your subject to each other and to what you draw. Consider the ideas in this chapter as you make those comparisons.

To fully understand all the techniques in the book, try each one as soon as you're able to. You can apply many of the techniques to the exercises on pages 20 and 21. Think of them as structured doodling.

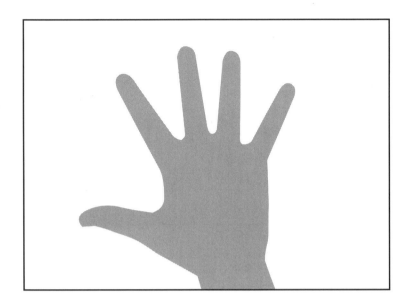

Seeing Solid Shapes and Space Shapes
Look at one of your hands with the fingers spread, and you'll see several shapes.

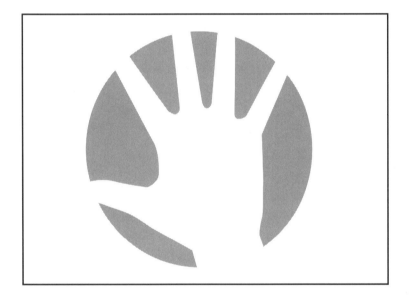

Look at the space around your hand, and you'll see other shapes.

Whether it's your hand or an island in the ocean, every object is surrounded by space. To be more visually alert, alternate between drawing the shape of an object and drawing the shape of its surrounding space.

If a shape is made of many smaller shapes, it also has many surrounding space shapes.

"Positive" and "Negative" Space
The terms commonly used to talk about solid shapes versus space shapes are "positive space" and "negative space." I like to think more simply when I draw, so I avoid these terms.

The circle contains a close-up of a space shape.

Here's an example of a space shape between objects.

CHAPTER 1 ⊜ THE MAGIC OF SEEING LINES AND SHAPES

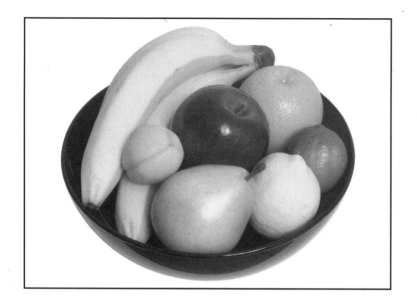

Seeing Combination Shapes

When you draw, look for basic shapes and forms – and their variations – within objects. If you're working with a combination of objects, try to see the entire combination as one shape. The largest combination shape in this photo is similar to an oval or ellipse.

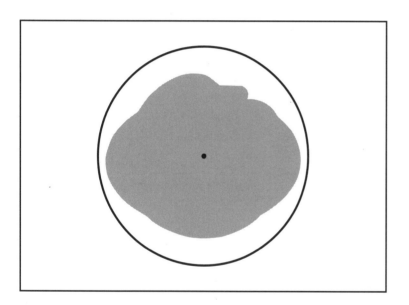

To draw from life, you need to convert three-dimensional forms into flat (but not "flat-looking") two-dimensional shapes. To instantly see a form as if it were flat, close one eye.

To flatten a group of forms and see it as one shape more easily, **first** visualize a circle around it. **Next** envision a small dot at the center of the circle. **Then**, for a few seconds, try to see the circle, the group of forms, and the dot at the same time.

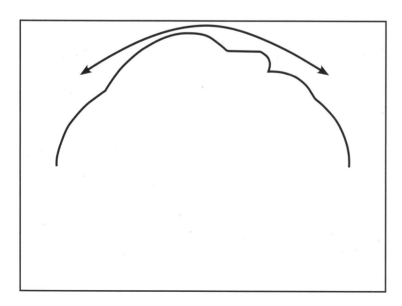

To start a drawing, begin with the largest shape that you can see. Lightly rough in its outline with a pencil, and then refine it using your eraser as a drawing tool along with your pencil. You will be able to use this main shape as a point of reference for the rest of your drawing.

To refresh your visual awareness as you draw, switch back and forth between different parts of your drawing. You can also refresh your awareness by stepping back and looking at your drawing from a distance. (You're more likely to step back frequently if you draw while standing at an easel.) By stepping back even a few feet, you will see your work from a contrasting perspective.

Resist the urge to draw small details. First place objects correctly on your paper. Placing objects usually involves trial and error and some erasing. If you draw minor details too soon, all of your hard work could go to waste.

Light outlines are easy to erase, but it's more difficult to erase dark or detailed pencil marks.

Using an Eraser
Just as a pencil is a drawing tool, think of your eraser as a drawing tool. Use it to help shape the objects in your drawings.

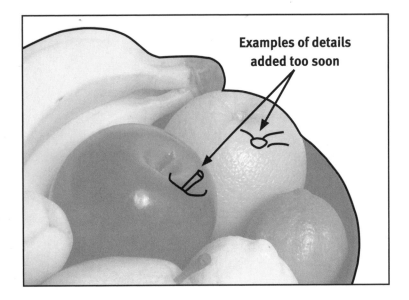

Examples of details added too soon

Continue by drawing larger shapes and eventually progressing to smaller ones.

TIP: Professor Hoyt L. Sherman once told Ohio State University's football team, "Keep your eye on the ball, but don't fail to keep your attention on the whole field." When drawing, try to see each line as part of an overall shape.

Always work from large to small and from general to specific. Draw the details last.

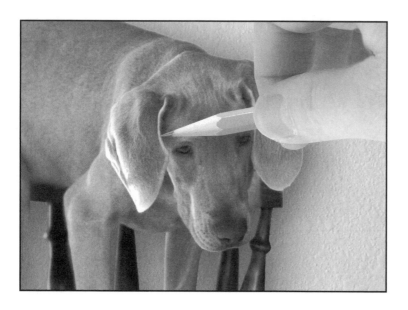

Comparing Widths and Heights

To help you see the proportions of a shape, compare its width to its height. Make the comparison mentally or with a pencil (or another straight object).

It's easiest to take pencil measurements at the beginning of a drawing, because that's when you draw the longest lines.

Here a pencil is used to compare the width...

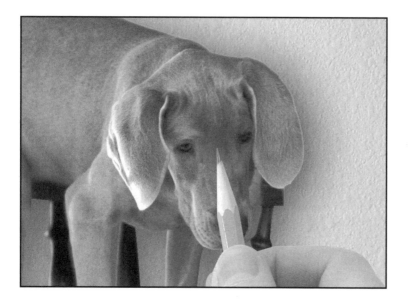

...and the height of a dog's face.

To compare the width and height of a shape with a pencil, **first** hold the pencil near the eraser between your thumb and fingers with your arm fully extended and the elbow locked. Don't tilt the pencil forward or backward. **Next** close one eye, and line up the pencil tip with one edge of the shape's width. (See the example above.) Work your thumb and fingers across the pencil to the place that marks the other end of the shape's width. **Then** compare your pencil reference to the shape's height. (See the photo to the left.) Note that if you're physically close to your subject, this sighting technique won't work.

You can also compare the width and height of a shape by visualizing a square or a rectangle around it. To help you compare the width and height of an imagined rectangle, judge roughly how many squares would fit within it. Make the sides of the squares equal to the short ends of the rectangle.

One whole square plus a part of a square would fit within this rectangle

> **TIP:** If you have a subject that won't stay still while you're drawing, such as a pet, take a photograph of it and draw from that.

Comparing Lengths Against a Fixed Length

To measure the relative sizes of the parts of an object, compare the lengths of its parts to a fixed reference length. This step gives you the general proportions of the object. For accuracy, make comparative measurements often.

Try this: Mentally compare the length of one of the parts of the dog (such as its tail) to its other parts.

To compare part lengths with a pencil, **first** pick a fixed reference length on an object. **Next** match the pencil to that length. The fixed reference length in this example is one of the dog's legs.

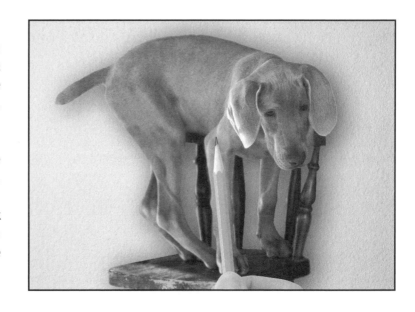

Then using the pencil, compare the fixed reference length to other lengths on the object. Here, the fixed reference length, as determined above, is compared to the dog's tail and to its head.

TIP: To sight more accurately, close one eye.

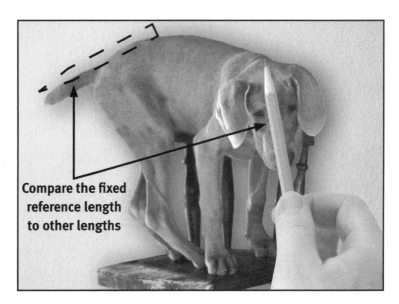

Compare the fixed reference length to other lengths

When a length is much shorter than the length that you're comparing it to, judge roughly how many shorter lengths would fit within the longer one.

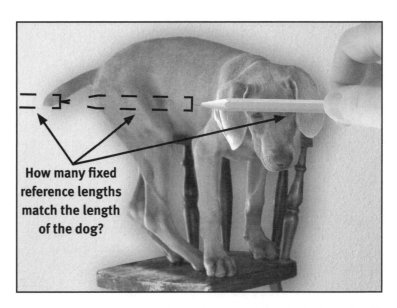

How many fixed reference lengths match the length of the dog?

Redrawing

When artists start their drawings, they sometimes draw faint trial lines in pencil. These lines are then erased or covered by darker lines. In the image to the left, you can see that several lines have been redrawn.

To speed the drawing process, erase the original lines later. If you decide to keep them, the original lines can add a sense of motion and vitality to your drawings. If you find yourself redrawing more than you'd like, try mentally rehearsing your pen or pencil strokes before you make them.

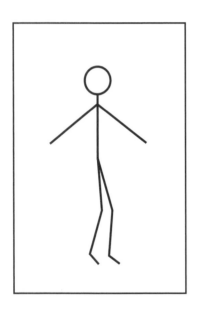

Redrawing and Motion

The eye's gift for noticing motion is key to the process of redrawing. When you draw, let your eyes move back and forth between your subject and your drawing. Lines that closely match will appear motionless, but lines that don't closely match seem to move. These lines attract your attention.

Try this: Shift your eyes back and forth between the stick figures to the left. Notice how your attention is drawn to the arms and their apparent movement.

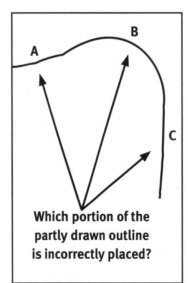

Which portion of the partly drawn outline is incorrectly placed?

Seeing Mistakes Using Eye Movement

If you've drawn a line that appears to move when you shift your eyes from the subject to your drawing, notice where it appears to move. Use this knowledge to redraw it or just to adjust the location of your next line.

Try this: Shift your eyes back and forth between the photograph and the drawing. Notice which portion of the covered wagon's partly drawn outline is incorrectly placed. (Section C is off.)

Comparing Lines

Comparing line lengths is one way to better see the characteristics of lines. Comparing line angles and line shapes are two more ways.

Try this: Compare the lengths of the drawn curved lines, compare their angles (as indicated by the dashed lines), and then compare their shapes. Eventually, you'll automatically observe a line's length, angle, and shape together when you compare it to another line. (See more about angles on pages 24–29.)

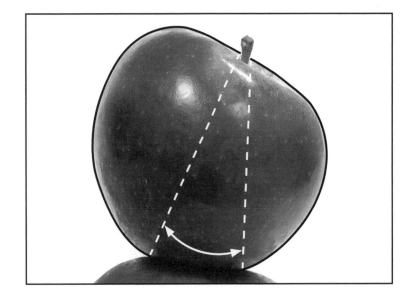

Noticing Scale

While concentrating on drawing a shape, you might overlook its most obvious quality: its relative size or its scale. To avoid scale errors, continually compare shapes to other shapes, and make a habit of comparing the smaller shapes within an object.

In the image to the right, notice how the drawn outline of the triangular rock is the correct shape but isn't drawn to the same scale as the other drawn rock. Shift your eyes back and forth between the photo and drawing, and the scale error will stand out.

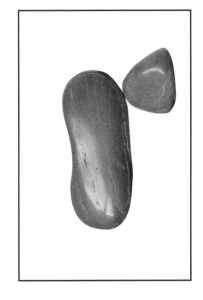
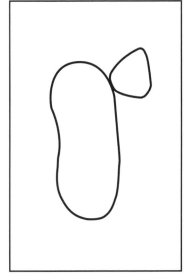

Stretching Your Imagination

This technique will develop your ability to see and remember shapes. When you can, view a shape as if it were the side view of a cartoon nose or mouth. (The technique exploits your experiences of "reading" the facial expressions of people and animals.) You can also try visualizing a shape as if it were part of a familiar object such as a rock or a tree.

The illustration to the right shows how the outlines of the toy bear's ears have been used to draw cartoon noses.

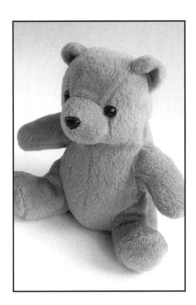
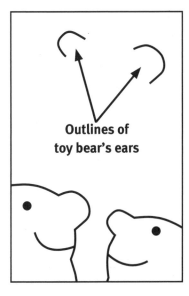

Outlines of
toy bear's ears

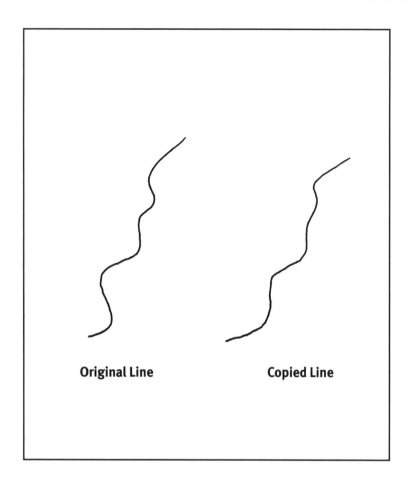

Original Line **Copied Line**

Exercise 1-1

To test and improve your ability to draw lines, **first** draw a line with a few curves. **Then** draw it again beside your original line. Compare your new line to the original.

Repeat this exercise until you feel ready to move on to spirals in the next exercise.

> **Engaging Your Sense of Touch**
> Each time you look at your subject, imagine that your pen or pencil touches or glides directly on top of the part you're drawing. This makes it easier for you to mentally project lines and shapes onto your paper.

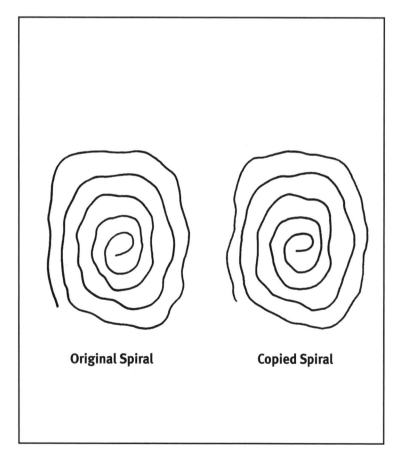

Original Spiral **Copied Spiral**

Exercise 1-2

To test and improve your ability to digest all the information in a subject, **first** draw a spiral. **Then** draw it again beside your original spiral. (Observe the part of the line that you're drawing in relation to the whole spiral, and notice the shapes you're making within the spiral walls.) Compare your new spiral to the original.

Repeat this exercise until you feel ready to move on to simple shapes in the next exercise.

> **Drawing Intricate Lines with Patience**
> To increase your patience while drawing short, detailed lines or parts of lines, visualize them as part of a mountain slope (see page 22). Mountain slopes contain nearly every type of short line imaginable. Observing intricate lines in this way slows you down to a pace suitable for detailed drawing.

Exercise 1-3

To test and improve your ability to draw shapes, **first** draw a simple shape no more than 4" long. **Then** draw it again beside the original shape. Compare your new shape to the original.

Repeat this exercise until you feel ready to move on to the more complex shapes in the next exercise.

A Tip from Michelangelo

When asked how he created statues, the painter and sculptor Michelangelo once said, "In every block of marble, I see a statue as plain as though it stood before me....I have only to hew away the rough walls that imprison the lovely apparition to reveal it to other eyes as mine see it." Imagine that your drawing already exists under an ultra-thin veil that, as you draw, you're gently scratching away.

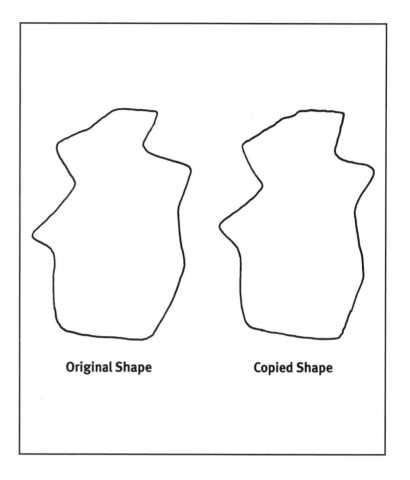

Original Shape **Copied Shape**

Exercise 1-4

To further test and improve your ability to draw shapes, repeat the above exercise, but make your shapes more complex.

As you progress through the book, keep coming back to this exercise – at least until you begin the more advanced exercises. Repeatedly create and copy shapes so that you can see the concepts in action.

Refreshing Your Visual Awareness Instantly

To refresh your visual awareness while your pen or pencil is still in motion, look at a line as if it were part of a hiking map (see page 23), and alternate between thinking of the line as a road and as a river – or as a path and a stream – on the map. This type of visualization and the others described in this chapter will help you take your mind off your performance while drawing. They will get you to focus on seeing with a different viewpoint.

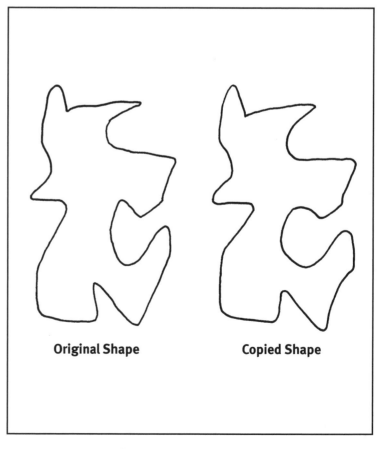

Original Shape **Copied Shape**

2
Creating Points of Reference

Now that you're able to see lines and shapes with greater clarity, you need to be able to place them accurately. This chapter shows you how to use your sense of balance as you create points of reference. A shape, including the simple shape of a dot, can be a point of reference. So can a line.

When you place a line, one of the first things to do is locate its endpoints. You could analyze it in other ways, too, but realize that drawing a line is like walking between two points. As you move from one point to another, you can depend somewhat on automatic processes. You don't need to ponder every step.

Measuring Angles with Your Sense of Balance

To remain balanced in an upright position, on your hands or on your feet, you need a flat base.

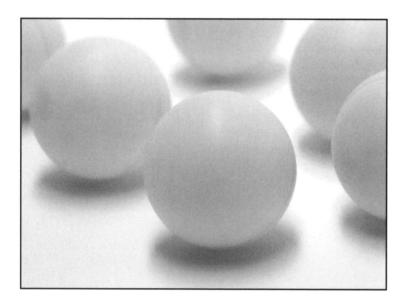

Many objects aren't obviously connected to a flat base. Those objects – such as the ping-pong balls to the left – seem unstable at first glance.

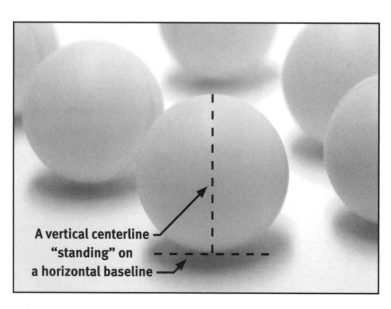

A vertical centerline "standing" on a horizontal baseline

We make such objects appear stable by mentally balancing them around a vertical centerline that "stands" on a horizontal baseline. We visually balance stationary objects without consciously thinking about it.

If you visualize a point in space...

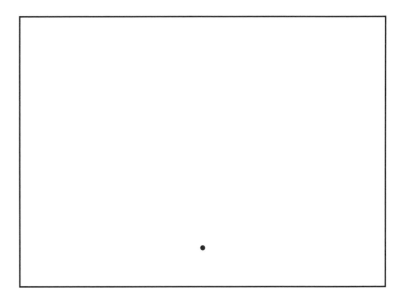

...you tend to balance it, too, with vertical and horizontal lines.

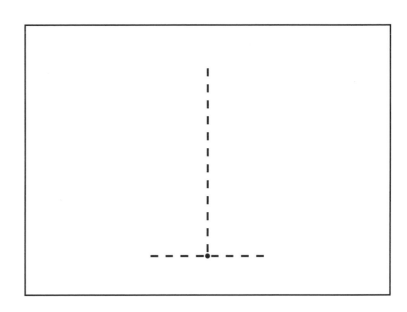

You rarely actually visualize the paired lines, but you "feel" them because of your sense of balance. Consciously comparing any line to paired vertical and horizontal lines helps you to measure its angle.

Measuring Straight Line Angles

To measure the angle of a straight line, **first** mentally connect one of its ends to a vertical line where it "stands" on a horizontal baseline. **Then** observe whether the line you're measuring is closer to the vertical or the horizontal reference line.

Notice that the bottom right edge of the box is closer to the horizontal reference line.

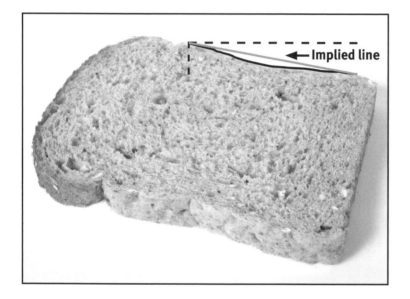

← Implied line

Measure the angle of an irregular line in the same way.

An **implied** straight line exists, in the imagination, between any observed pair of points. To more easily measure the angle of an irregular line, visualize the implied straight line between its ends.

In this example, notice that the horizontal reference line is reversed and is above rather than below the vertical reference line.

You might be unsure whether a straight line is closer to being vertical or horizontal. To check, visualize a rectangle – with vertical and horizontal sides – and connect the straight line to two of its corners. If the rectangle is taller than it is wide, the line is closer to being vertical. If the rectangle is wider than it is tall, the line is closer to being horizontal.

If the rectangle is as wide as it is tall, it is actually a square. In that case, the angled line is midway between being vertical and being horizontal.

Measuring Curved Line Angles

To measure the angle of a curved line, **first** visualize the implied straight line that connects its ends. **Next** visualize one end of that implied line connected to the vertical and horizontal reference lines. **Then** observe whether the visualized implied line is closer to being vertical or horizontal.

Notice that the curved black line is closer to being horizontal.

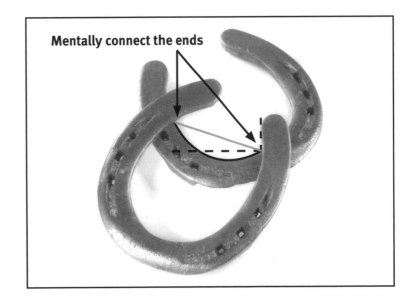

Mentally connect the ends

You can also compare any line to a pencil or a ruler. If the line is closer to being vertical, hold the pencil vertically. If it's closer to being horizontal, hold the pencil horizontally.

Notice that the curved line along the bottom of the watering can's spout is closer to being vertical.

Using a Pencil to Measure Angles

When you measure an angle by comparing it to a pencil held vertically or horizontally, close one eye and hold the pencil near its eraser. Don't tilt the pencil forward or backward.

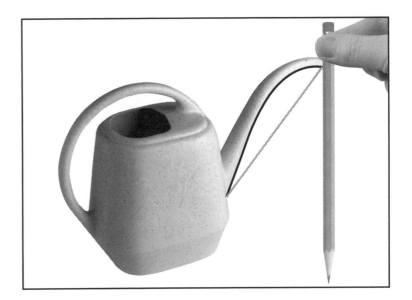

To help you judge whether a curved line is closer to being vertical or horizontal, visualize a rectangle and connect the curved line to two of the rectangle's corners.

More About Comparing Line Lengths

Here's an advanced way to compare the lengths of lines that aren't straight: Compare only the lengths of the implied straight lines. (See "Comparing Lines" at the top of page 19.)

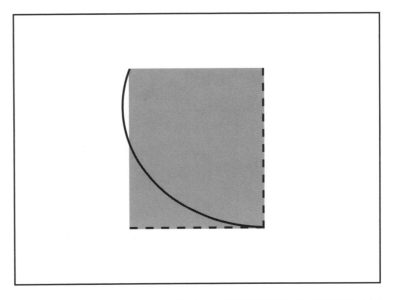

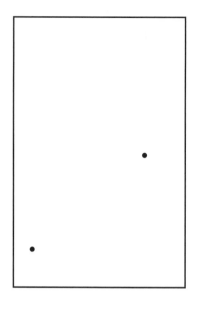

Visualizing Rectangles for More-Accurate Angles

When you can visualize straight lines with ease, you're ready to measure the angles of all types of lines more accurately.

Try visualizing a straight line between each pair of dots to the left.

Visualize a straight line between each pair of these dots. This time the interfering objects make your task more difficult.

Now visualize straight lines between these dots while using the rectangle visualization method described at the bottom of page 26. Imagine the endpoints of each line at diagonally related corners of each rectangle.

Using a rectangle as a point of reference can help you visualize implied straight lines whether they're visually obstructed or not. Visualized rectangles also help when you need to place one or both of the endpoints of any type of line.

In these images, notice the four triangles formed by the rectangles and lines. Instead of visualizing a rectangle around a line, you could visualize a right-angle triangle against it.

You can visualize a line that's vertical or horizontal, or nearly so, as one side of a rectangle.

Fine-Tuning Angles

To make it easier for you to draw a line at the correct angle, draw a dot as a start point and another dot as an end point. If you see that one of the dots isn't well placed, replace it or ignore it.

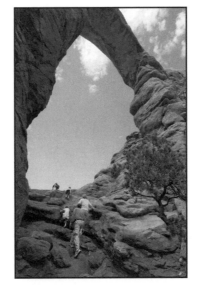
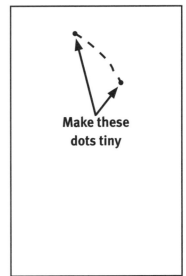

Make these dots tiny

If you already know where you plan to start a line, just draw a dot to indicate where you plan to end the line.

To make it easier to place a dot, hover your pen or pencil above your paper. As you look back and forth between your subject and your drawing, move the pen or pencil until it's above the "right" spot.

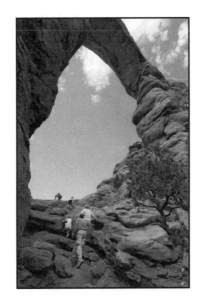
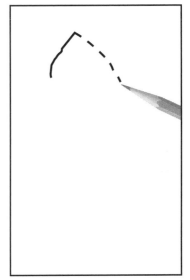

To fine-tune a line's angle using a pencil edge, **first** close one eye and hold the pencil so that the edge appears to touch both ends of the line on your subject. **Next**, while keeping the pencil at the same angle, bring it in front of your drawing and match the pencil edge to the point on your paper where the line will begin. **Then**, since the end of the line will fall somewhere along the pencil edge, you can judge the line's length and know where to mark its end.

It's easiest to keep the pencil at a fixed angle if you hold it at arm's length with your elbow locked. To fine-tune the angles of long lines, use a ruler.

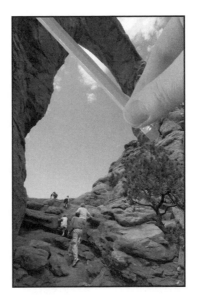
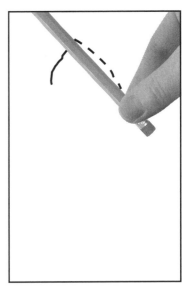

Using Diagonal Guidelines

Guidelines are straight lines that show how parts of a subject align with each other. You visualize guidelines on your subject...

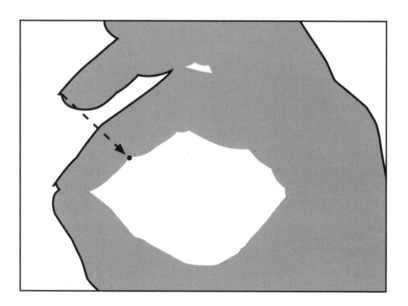

...and then on your drawing either visualize or actually draw them. You can also use straight objects that you hold, such as pencils and rulers, as guidelines.

In the image to the left, notice the diagonal or tilted guideline suggested by the dashed line. It pinpoints the start point of a line, which is marked in this example with a dot.

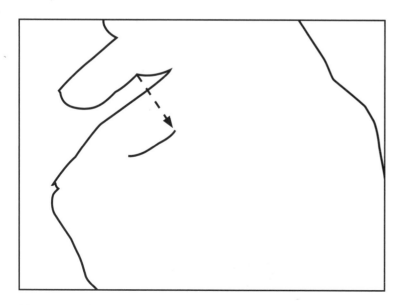

This next guideline pinpoints the other end of the line started above. You can use all three types of guidelines to locate the endpoints of lines, but most often, you'll probably use diagonal guidelines for that purpose.

Using Horizontal Guidelines

Notice the lower horizontal guideline extending across this picture. Using it as your point of reference, observe how closely the tops of the parrot's wings align horizontally. Create horizontal guidelines based on any point to help you see the relative horizontal alignment of parts of your subject. For accuracy, repeated horizontal **and** vertical alignments are critical.

Notice that the top guideline creates a section at the top of the parrot's head. Use guidelines at any angle to isolate a shape you want to draw.

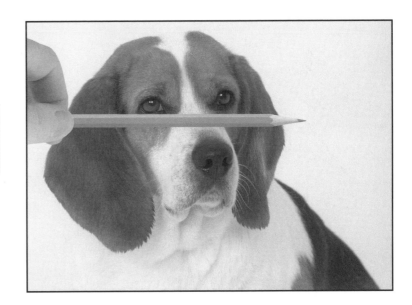

Compare the locations of the tops of the parrot's wings

Compare the distance from the pencil's edge to each of the dog's eyes. This guideline (the edge of a pencil) makes it easier to notice that one eye is higher than the other.

> **TIP:** Create a horizontal guideline, based on any point, to enhance your ability to draw lines and shapes near it.

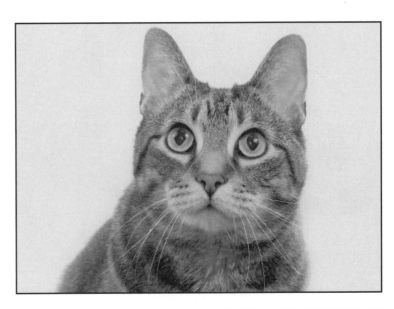

Try it yourself. Picture a horizontal guideline beneath the cat's eyes, and use it to help you decide which eye is higher. (Notice in this image what appears above and below your imagined guideline.)

> **Guideline-Visualization Practice**
> Observing pictures in magazines is a good way to practice visualizing guidelines. As you flip through a magazine, stop now and then to visualize guidelines and become more aware of the relationships of lines and shapes within pictures.

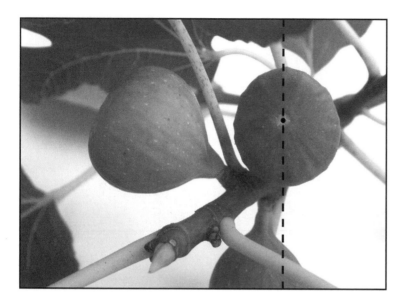

Using Vertical Guidelines

Notice the vertical guideline extending from the top to the bottom of this picture. Vertical guidelines help you in the same way as horizontal guidelines, and both types of alignment are equally important.

To help you draw each half of symmetrical objects (or nearly symmetrical objects, such as these figs), divide them with vertical, horizontal, or diagonal guidelines. You can use guidelines to check for symmetry: even if you "know" that an object is symmetrical, it may not be when you check it.

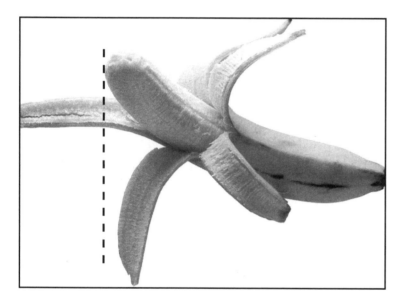

If you had already drawn the outline of the top of the banana in this image, a vertical guideline would make it easier for you to draw the outline of the lower part of the peel.

TIP: Create a vertical guideline, based on any point, to enhance your ability to draw lines and shapes near it.

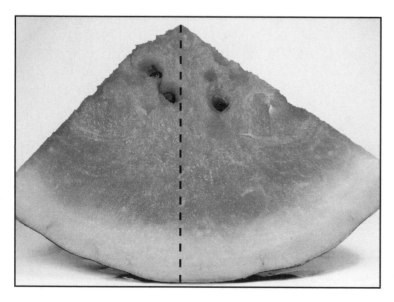

You could draw the outline of this slice of watermelon by first dividing it into two sections with a guideline. You could then work your way around it, drawing one section of the outline at a time. The vertical guideline would also make it easier for you to place the indentations and seeds.

Choosing Where to Use Guidelines

The best points of reference for guidelines are where lines end, overlap, or change direction (see the circled points in the image to the right). Other good points of reference include the top, bottom, left, and right boundary of a curve, as well as the midpoint of any line.

You can also use guidelines in a more general way when lines don't offer specific points where you need them. Notice where these five guidelines are placed, and observe the space shapes (the gray sections) created by two of them.

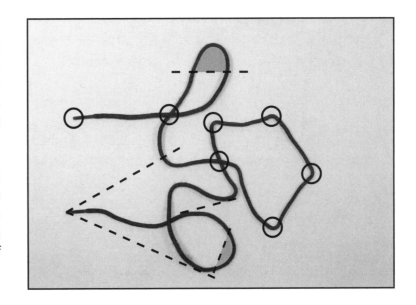

Combining Guidelines

Combine guidelines to enhance your ability to draw lines and shapes near them. For example, use two guidelines as horizontal and vertical references that either cross or just meet. You can also try using side-by-side parallel guidelines.

Notice how these guidelines cross at a point on a partly drawn paper bag.

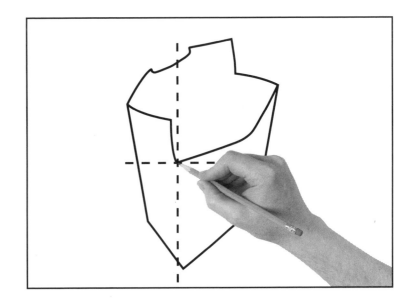

Using Many Guidelines for Greatest Accuracy

To locate a point more accurately, use more than one guideline. The more guidelines you use, the more accurate your drawing will be.

As you become more experienced, you'll automatically scan your drawings for points of reference to help you place guidelines and triangles.

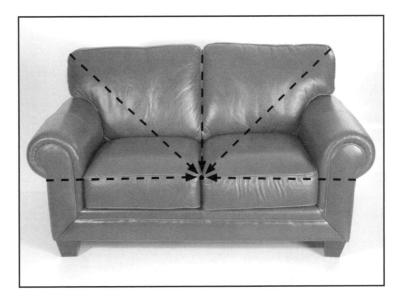

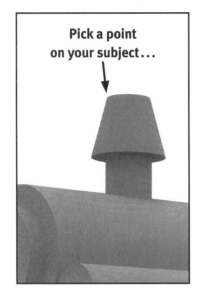

Pick a point on your subject...

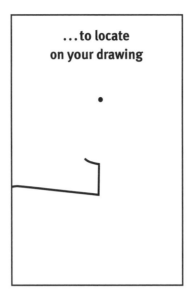

...to locate on your drawing

Using Two-Sided Triangles

Relate points on your subjects to points on your drawings to make lines easier to draw. You can locate points with guidelines, but you can locate them more reliably with two-sided triangles.

> **How Can Two Sides Make a Triangle?**
> For any two-sided triangle, the third side is always implied – causing it to be imagined – at the open end between the two visible sides.

To use this technique, **first** pick a point on your subject that you want to locate on your drawing.

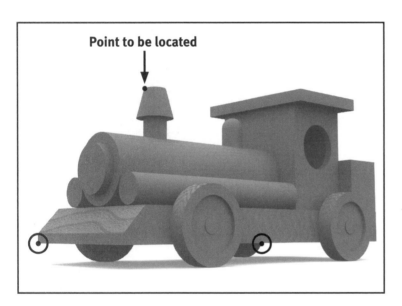

Point to be located

Next pick two points on your subject on parts that you've already drawn. (See the subject example to the left and the drawing example below.) These three points automatically form a triangle on your subject. (In the next chapter, you'll learn how to use triangles to **start** your drawings.)

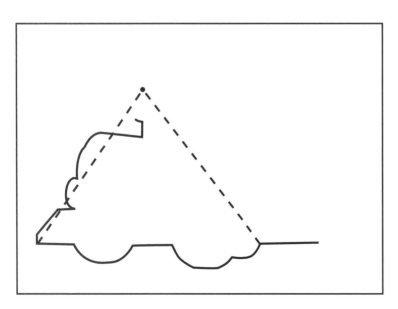

Then, on your drawing, visualize or draw the triangle formed in the previous step. For this method to work, you need to visualize or draw only the two sides of the triangle that connect to the point you want to locate.

Visualizing Triangles as Two Guidelines

You might find it easier to think of two-sided triangles simply as two intersecting guidelines.

To use this technique, **first** pick a point on your subject that you want to locate on your drawing.

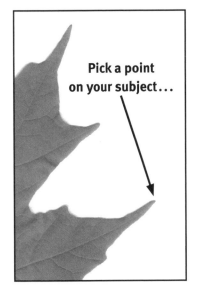

Pick a point on your subject...

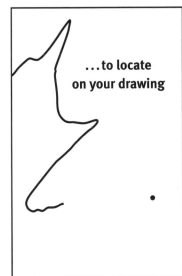

...to locate on your drawing

Next, also on your subject, pick two points on parts that you've already drawn. (See the subject example to the right and the drawing example below.) **Then** visualize two sides of the triangle – formed by the three points – as guidelines that meet at the point you want to locate on your drawing.

> **TIP:** You don't need to visualize both guidelines at the same time. By shifting your awareness back and forth between them as you judge their angles, you create, in effect, a two-sided triangle.

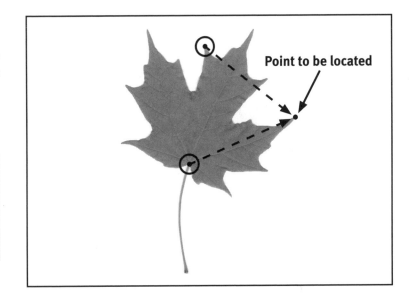

Point to be located

Next, on your drawing, visualize one of the guidelines lengthened so that it extends beyond the point you want to locate. **Then**, visualize the other guideline lengthened so that it extends beyond the same point as well. The point you're locating on your drawing exists where the two guidelines cross.

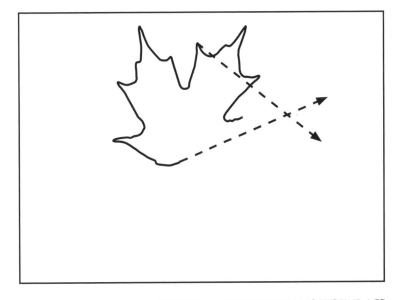

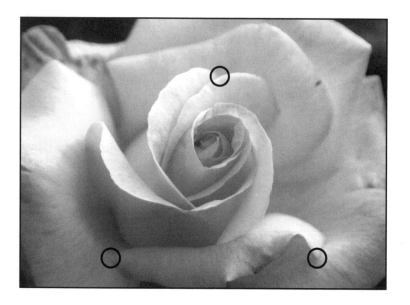

Choosing Where to Use Triangles

As with guidelines, the best points of reference for triangles are where lines end, overlap, or change direction. And, again as with guidelines, other good points of reference include the top, bottom, left, and right boundary of a curve, as well as the midpoint of any line.

This example has many good points of reference. Three of them are circled to form a large triangle. Use a large triangle, two endpoints at a time, as the base for two-sided triangles that you create to locate points. Once you've placed two endpoints of a large triangle, use them to place the third.

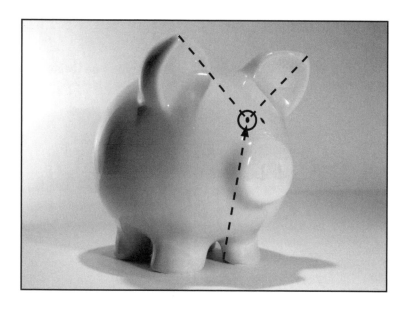

Combining a Guideline with a Triangle

If you drew an outline of this pig figurine and wanted to pinpoint the location of the circled eye, you could create a two-sided triangle extending from the tips of the ears to the eye.

To pinpoint the eye with the additional help of a guideline, you could create a guideline that extends from one of the pig's front legs to the circled eye.

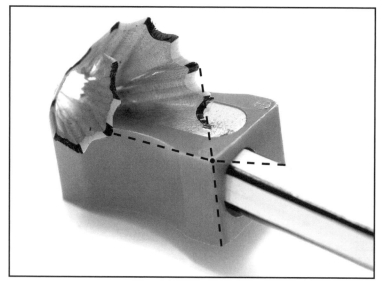

Using Several Triangles for Greatest Accuracy

As with guidelines, using more than one triangle helps you to locate a point more accurately. The more triangles you use, the more accurately you'll draw.

> ### Triangles Versus Guidelines
> Use a single triangle or two guidelines together to draw to scale with accuracy. Using a single guideline is not as reliable. If you use a guideline with another point of reference – such as a shape or part of a shape – you can achieve excellent results.

More Ways to Use Simple Shapes

The simplest shape with straight sides is the triangle. A rectangle is almost as simple. Visualize or draw either shape around lines and other shapes to help you draw them. To visualize a rectangle more accurately, extend a guideline between two corners, as shown to the right.

Placing a triangle or a rectangle around a line or another shape sometimes creates new shapes that you can use, too. For example, notice the curved line at the far right with shapes numbered 1 and 2 around it. Seeing the line as part of shape 1 and then shape 2 will help you to draw it.

More about Visualizing Shapes Within Lines

Implied lines often create implied, or imagined, shapes. To help you observe lines in a memorable way, visualize implied shapes within them. Implied shapes can act as points of reference that naturally divide lines into shorter sections, making longer lines easier to draw.

For example, notice the line to the right. To help you draw it in parts, you could visualize three implied shapes, as suggested by the gray shapes to the far right. When it's practical, use one implied shape to draw one whole line.

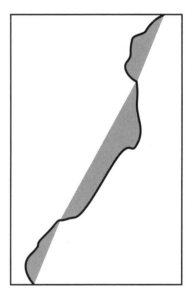

Avoiding Narrow Triangles

Avoid using narrow triangles, but when you have to use them, you'll have better success with the two-guideline method described on page 35. Triangles that are closer to being equilateral are easier to visualize accurately. (An equilateral triangle has three equal sides.)

To practice creating the shape of an equilateral triangle, place three dots equally far apart. To check your results, rotate your paper. The shape implied by the group of dots should look the same no matter which dots create the base.

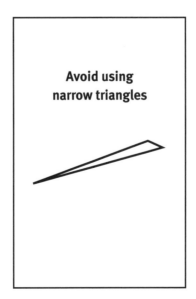

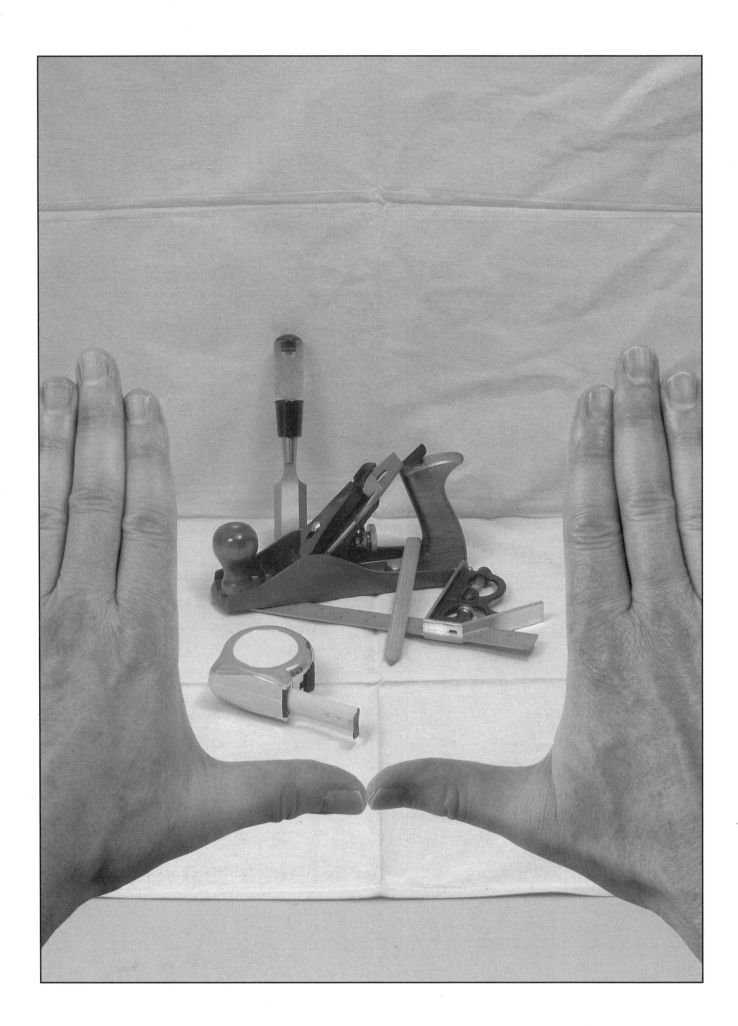

3
Building a Drawing from the Ground Up

You wouldn't start building a house by randomly hammering nails into boards. You would start with a blueprint, a plan. It's the same with drawing. Drawing from life goes more smoothly with planning, and this chapter will guide you in starting and organizing your drawings.

There might be times when you leap ahead to complete an immediate sketch of a subject – a hummingbird, for example – before it moves from sight. Such times demand that you be more spontaneous, but you'll have fewer problems when you plan ahead.

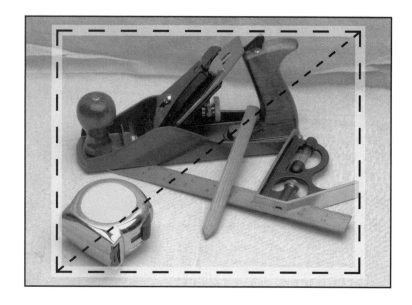

To take full advantage of your drawing paper, fill it with your subject. For wide subjects, position your paper horizontally in "landscape" view. For tall subjects, position it vertically in "portrait" view.

To place your subject, **first** visualize a rectangle around its edges. **Next** visualize a guideline between two diagonal corners of the rectangle.

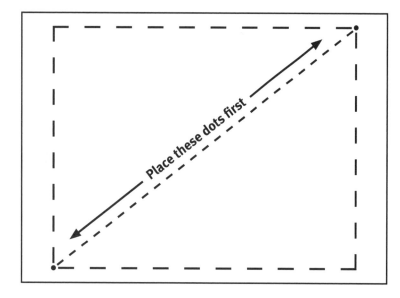

Place these dots first

Then mentally transfer the rectangle and guideline together to your paper. As you do, decide where to place your subject and how much space to give it. Consider the space shapes (see pages 12 and 13). **Next** draw dots to mark the ends of the guideline. Use the edge of your pencil or a ruler to help you judge the guideline's angle.

As you judge the angle between the guideline's endpoints with a sighting object, you probably won't be able to extend your arm fully with the elbow locked. To make the sighting object span from endpoint to endpoint, you'll probably need to bring it closer to your face.

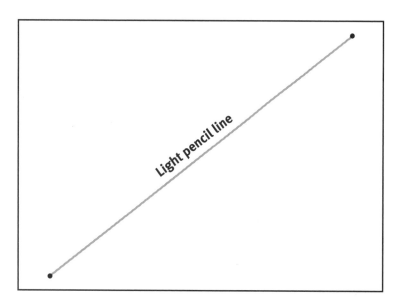

Light pencil line

To refine the position of the dots, **first** lightly draw a line between them. **Next**, sighting with the edge of your pencil again, relocate the dots if necessary.

Erase the line between the first two dots.

Next draw two more dots to mark the remaining corners of the rectangle. To help you place each of these dots, visualize a rectangle again, or visualize vertical and horizontal guidelines that meet.

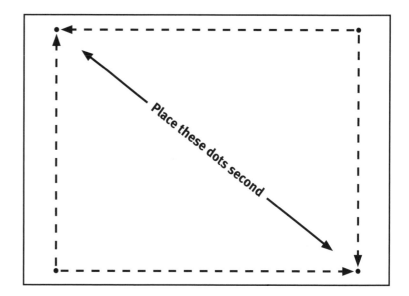

Then draw light pencil lines across the two short ends of the rectangle formed by the dots. The lines serve as guideposts at the sides (for landscape view) or the top and bottom (for portrait view) of your drawing.

Notice how the two guideposts create two implied lines between them. The guideposts and the implied lines create an implied rectangle.

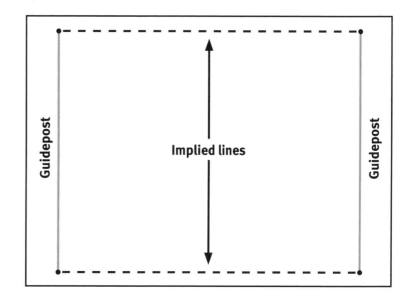

Next place the subject's outline while you refer to both the rectangle visualized around your subject and the implied rectangle on your paper. Use the space shapes as you refine the outline.

Erase the guideposts when you no longer need them.

Creating Cornerstone Shapes

A cornerstone shape is a small section of a shape drawn first to help create the rest of the shape in proportion.

Visualize or draw diagonal, horizontal, or vertical guidelines to help you isolate...

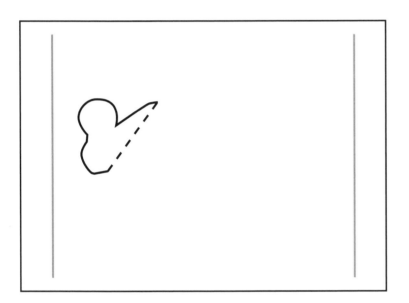

...and draw cornerstone shapes.

If you notice that a cornerstone shape isn't drawn accurately, refine it. Make your initial cornerstone shape a reliable and constant point of reference.

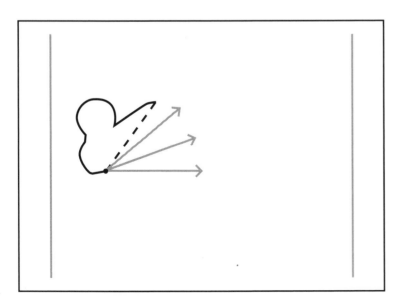

For another constant point of reference, pick a point on your initial cornerstone shape that will function as an anchor for additional guidelines. Pivot a guideline in any direction from that point, as suggested by the arrows in the image to the left.

Using Cornerstone Shapes

To help you draw a shape in proportion, use its cornerstone shape as a point of reference. Using the cornerstone shape as a starting point, "see" as much as possible of the whole shape on your drawing .

Whenever you draw a shape, visualize on your paper at least the section you're about to add.

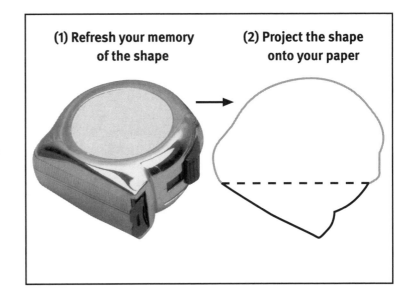

(1) Refresh your memory of the shape

(2) Project the shape onto your paper

Work back and forth on either side of a cornerstone shape for a fresh awareness...

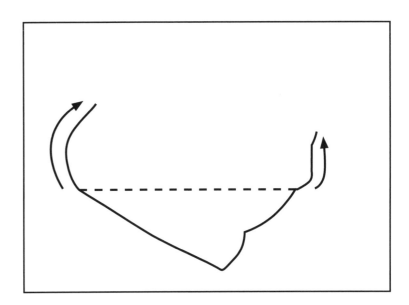

...until the shape is complete.

TIP: For extra accuracy, use the initial cornerstone shape (used to create the main shape) as a point of reference until you've drawn all of your subject's shapes.

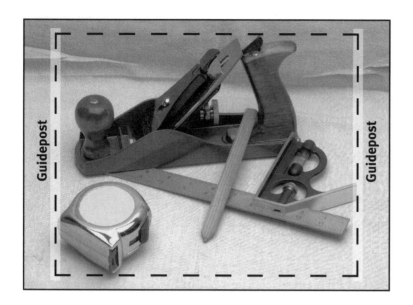

Creating Cornerstone Points

Cornerstone points are tools that will enable you to accurately draw lines. Use them as you draw any line or while you create lines that are parts of cornerstone shapes.

IMPORTANT NOTES: (1) After drawing a pair of guideposts on your paper, use the two short ends of a rectangle that you visualize around your subject as another pair of guideposts (see page 41). (2) Unless indicated otherwise, use both the drawn and the visualized pairs of guideposts together.

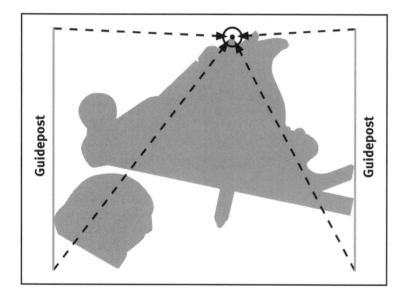

To create your first cornerstone point, **first** select a point on the outer edge of your subject roughly midway between its guideposts. (See the circled point in the image to the left.) **Next**, also on your subject, visualize guidelines extending from both ends of each guidepost to the point that you selected.

Then – moving now to your paper – visualize guidelines similar to the ones that you visualized on your subject. Make them touch all four ends of the guideposts on your paper and come together at a point. Mark this point with a pencil; it is your first cornerstone point.

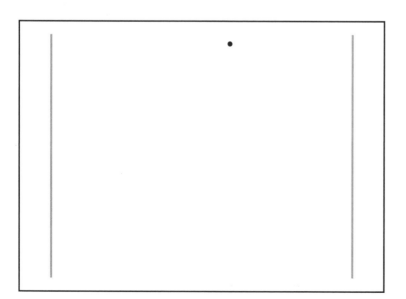

If you are drawing the subject shown at the top of this page, your paper now looks like this (see the image to the left).

Like guideposts, cornerstone points come in pairs. To locate the second cornerstone point, **first** visualize a guideline that starts at the first cornerstone point on your subject and ends at a point on the opposite edge of the subject. (See the spot marked with an X in the image to the right.) This will be your second cornerstone point.

Visualize a guideline between your first and second cornerstone points, and it should divide your subject roughly in half.

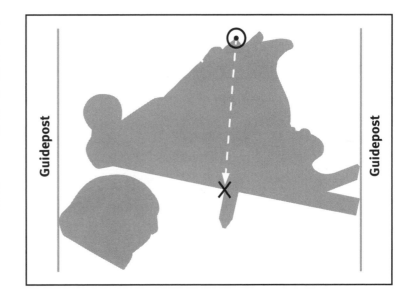

Next, visualize guidelines on your subject that extend from all four ends of its guideposts to the second cornerstone point you've selected. **Then** visualize these guidelines – and the guideline created in the step above – on your paper so that you can **now** mark the second cornerstone point. For greater accuracy, use a pencil or a ruler to help you judge the angle of your second cornerstone point in relation to your first.

> **TIP:** Use one guideline to judge the **angle** between the cornerstone points, and use the four guidelines from the guideposts to judge the **distance** between the cornerstone points.

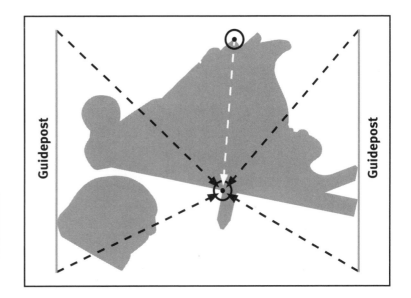

Next refine your cornerstone points, paying special attention to the angle between them. **The angle of the second cornerstone point in relation to the first is critical.**

When you're satisfied with the locations of the cornerstone points, erase the guideposts. If you're drawing the subject shown at the top of page 44, your paper now looks like this (see the image to the right).

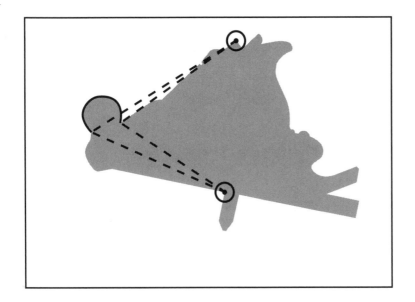

Using Cornerstone Points

To help you draw a line accurately, locate its ends with two-sided triangles based from cornerstone points. (If you prefer, you can use pairs of intersecting guidelines instead.) As you pinpoint the ends, mark them with a pen or pencil, or just mark them mentally.

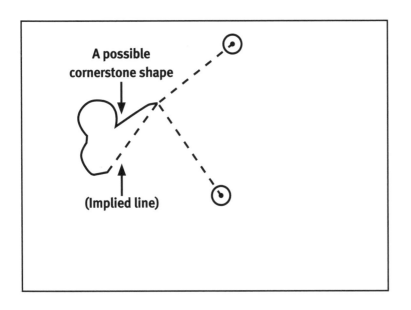

A possible cornerstone shape

(Implied line)

This two-sided triangle, based from cornerstone points, pinpoints only the end of a line. The line completes a possible cornerstone shape.

Using Cornerstone Points Selectively

Sometimes it's practical to use cornerstone points only to start a shape. Using cornerstone points even a few times during a drawing, especially to create cornerstone shapes, helps you to draw with more confidence.

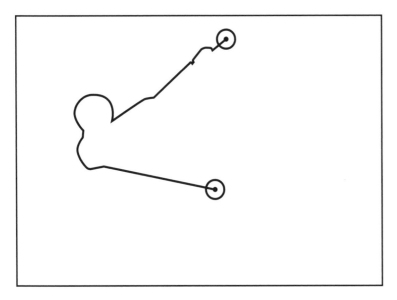

In this example, the first half of a shape is completely drawn, and its lines reach all the way to the cornerstone points.

This example shows another two-sided triangle based from a pair of cornerstone points. The triangle pinpoints the start point of a line, which is marked in this example with a dot.

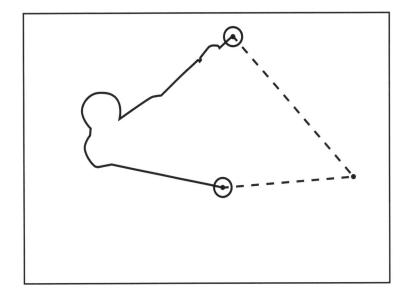

In this example, a two-sided triangle, based from cornerstone points, pinpoints the other end of the line started above. Both ends of the line are now marked.

Cornerstone Points Versus Large Triangles
Basing two-sided triangles from cornerstone points is similar to the method for using large triangles (described on page 36). Cornerstone points give you greater accuracy, but large triangles are easier to create.

Once you finish the lines of a main shape, you're ready to begin using the shape as a point of reference while you draw other lines with cornerstone points.

Creating More Cornerstone Points

Any two points that you can clearly see on both your subject and your drawing can serve as cornerstone points.

In the images to the left and below, the circled cornerstone points would help you draw the lines in the triangular space shape.

The cornerstone points divide the space shape roughly in half. You could draw the lines on each half separately, working back and forth toward the cornerstone points...

...until you had completed both halves.

When you create more cornerstone points, you can use your initial cornerstone points on the main shape to help you locate them.

Using Cornerstone Points with Care
Don't totally rely on cornerstone points. Remain aware of other points of reference that catch your awareness, such as the main shape and its cornerstone shape.

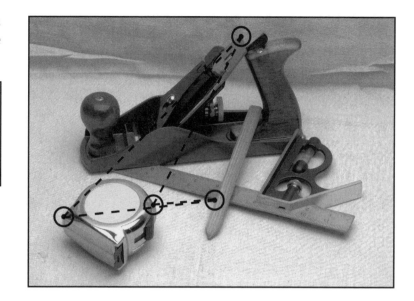

Cornerstone points on the tape measure (in the image above) divide it nearly in half. You could draw its outline by working back and forth with the help of cornerstone points.

Once you've drawn the main shape and most of the other shapes, you can begin drawing the lines that make up the background shapes. Once you've drawn all the shapes, you now have your blueprint or plan and can begin drawing details. Draw first the details that have longer lines and lines that help define an object's form.

"A line is a dot that goes for a walk."

– Paul Klee

Part Two
Mastering the Building-Block Lines

Part 2 of this book helps you draw what you see. It also builds your confidence for using the three types of building-block lines: straight, circular, and elliptic.

Chapters 4, 5, and 6 make up a miniworkshop on creating those special lines and drawing with them. In part 3, you'll learn how to use them to help you draw any other type of line.

10 Objects with Simple Lines

- Cardboard box

- Milk carton

- Candlestick

- Lamp

- Chair

- Book

- Bowl

- Glass

- Plate

- Wheel

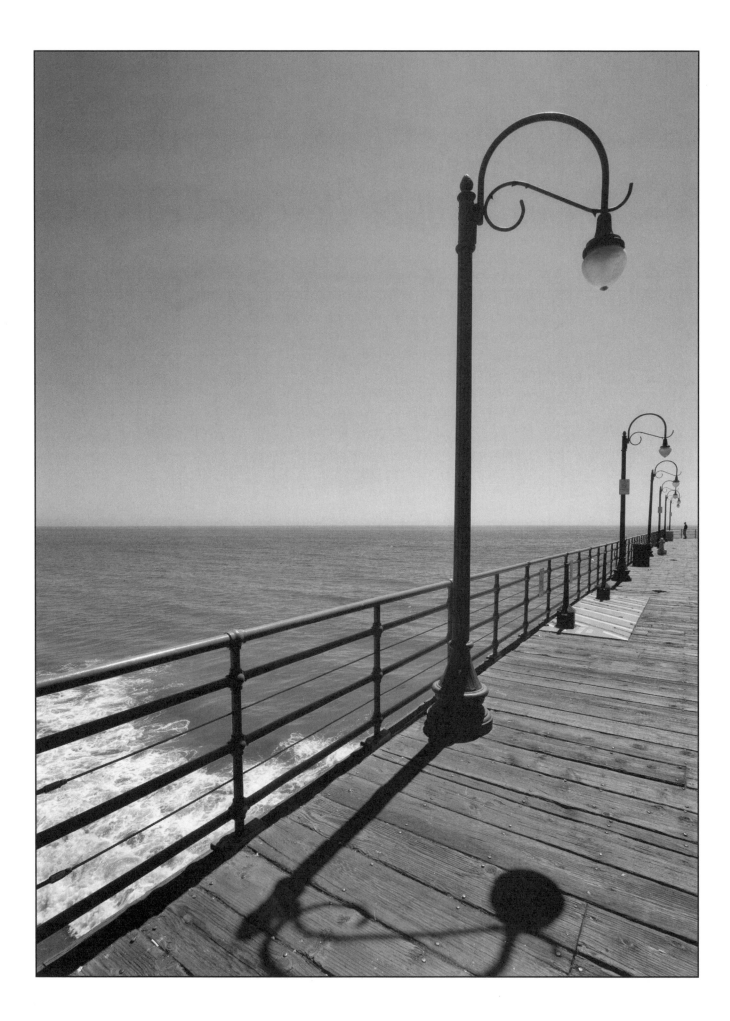

4
Mastering Straight Lines

Straight lines are continuous lines without curves. In this chapter, you'll learn to draw them with confidence. In the final chapter, you'll learn how to use a straight line with the other building-block lines as a special group of tools. Remember that your straight lines don't need to look perfect. Flaws can give drawings a unique character.

To prepare for what's next, try this experiment with a drinking glass. Hold a clear glass in front of the opposite page. Position the glass so that you see a straight line at its top, and match this straight line with the straight line formed by the horizon in the photograph. Now you're ready to begin learning more about straight lines.

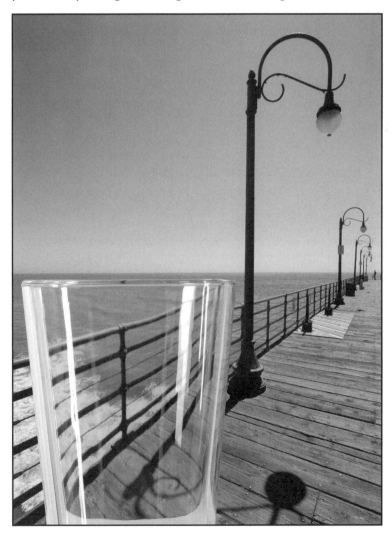

Seeing Straight Lines as Parts of Glasses

To help you observe, visualize, and draw straight lines, **first** imagine a clear drinking glass with an even rim across the top so that you see a straight line. **Next,** on your subject and then on your paper, match the top of the glass with the straight line that you want to draw.

If the straight line is shorter, your glass will be smaller.

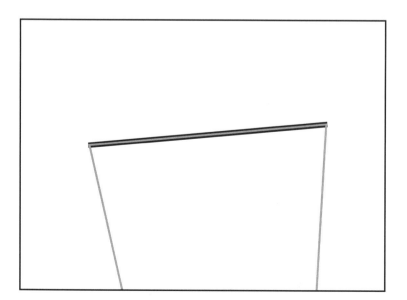

If the straight line is longer, your glass will be larger.

> #### Why Use a Glass?
> A glass is a familiar clear object that can help you draw any of the lines covered in part 2. (For drawing straight lines, you might prefer to use other techniques found in this and previous chapters.)

Visualizing a Glass from the Side

Make your imaginary glass look like the entire glass...

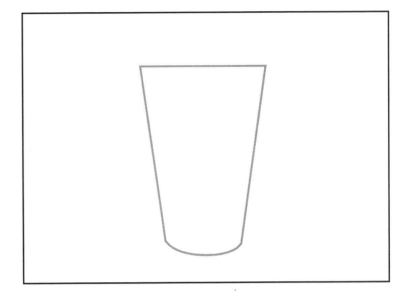

...or just the rim of a glass.

As long as you can see the rim, it can help you observe, visualize, and draw straight lines.

Seeing Straight Lines as Parts of Roofs

Here's another method to help you observe, visualize, and draw straight lines: Look at a straight line as if it were part of a roof, and draw it with that same awareness.

For example, you could see this straight line (the image to the left) as part of a steeply sloped roof.

And you could see this line as part of a roof with a medium slope.

This line could be part of a roof with a gentle slope.

Observing Horizontal and Vertical Lines
If the line you're observing is horizontal or vertical, or nearly so, you can visualize it as one side of a rectangle.

Seeing Straight Lines in Perspective

Perspective is the art and science of portraying objects on a surface so that they appear three-dimensional. It's beyond the scope of this book to offer much detail about perspective. Entire books discuss perspective alone. Even so, you'll draw more accurately if you remember this fact: Lines that are parallel in reality will appear to move closer together as they recede from your vision. Buildings offer you ideal opportunities to observe receding parallel lines.

In the photograph to the right, there are many sets of these lines.

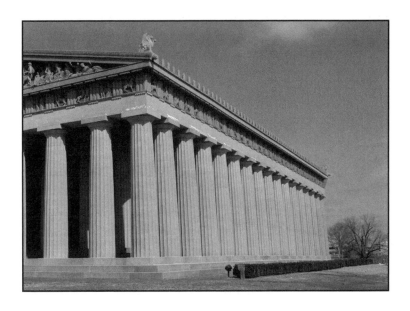

You can observe the same phenomenon with objects that are close by. Notice the receding parallel lines on this box of tissues.

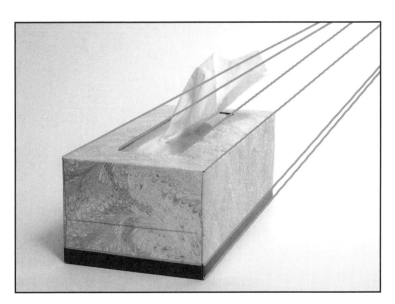

To avoid the type of perspective errors shown in the image to the right, pay attention to what you see as well as what you "know."

Seeing What You "Know"

In his book *Freeing Creative Effectiveness*, Bill Harvey discusses the mind's tendency to take common objects for granted. He contends that if you're familiar with an object that's very similar to the object you're viewing, your mind projects its stored image, and you won't truly see what's actually in front of you. As you look at your drawing subjects, take time to examine them with fresh eyes.

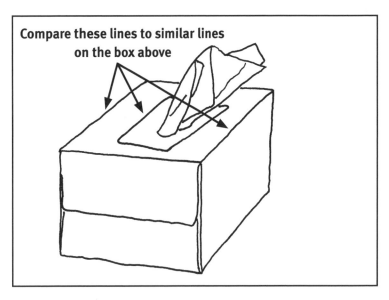

Compare these lines to similar lines on the box above

A Special Way to Draw Squares

To practice drawing squares, **first** visualize a square where you plan to draw it, with perpendicular guidelines crossing through its center. Maintain this visualization for all remaining steps.

Why Draw Squares?

If you practice drawing squares, not only does it become easier to draw them, but you'll also find it easier to visualize and draw rectangles and straight lines.

Next draw one side of a square from guideline to guideline. **Then** draw a second side continuing from the first. Make sure that your guidelines stay perpendicular (at right angles) to each other.

Together, the first two sides make a two-sided triangle with one right angle and two equal sides.

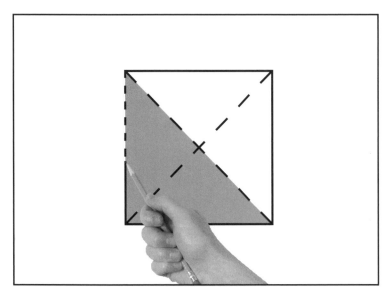

Next draw the remaining two sides of the square. As you draw them, you make another two-sided right-angle triangle.

Create squares at various angles. In other words, tip some of them.

Drawing Straighter Lines

As you draw a straight line, focus on where you want it to stop instead of where you're drawing. Much like the act of catching a ball, your hand moves reflexively in a straight line if you know where it's going to arrive.

Evaluating Your Squares

To evaluate your squares, rotate them one-quarter turn and observe, for each square, whether one dimension looks longer than the other. As you assess them, focus more on their shapes than on how straight the sides are. Few people are able to draw perfect squares without a ruler or a template.

In fact, for most drawings, you won't want to make perfectly straight squares or lines, since they look mechanically drawn. Practice drawing **nearly** perfect squares to help you draw whatever type of square or straight line you're likely to need.

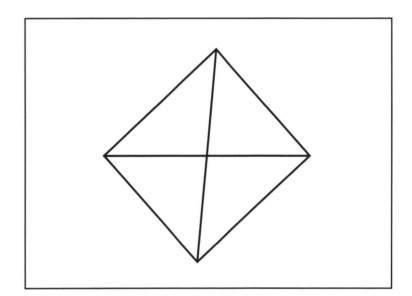

You can also evaluate your squares by drawing crossed straight lines between their corners and then observing whether or not those lines are perpendicular. If they aren't, the shape isn't square.

To make it obvious whether the crossed straight lines are perpendicular, turn each square so that one of its lines is flat. (See the example to the right.)

This example, on the other hand, shows what crossed straight lines look like inside an accurately drawn square. Compare them to the crossed straight lines in the shape just above.

Why Work with Basic Shapes?
The equilateral triangle, the square, and the circle are basic shapes. You'll find them and their variations within many objects.

Exercise 4-1

To test and improve your ability to draw straight lines, draw real objects. Collect some items with straight lines such as boxes, rulers, milk cartons, and books.

Place one of the objects in front of you, and tape your paper to your drawing surface. Draw the object with an emphasis on its straight lines.

When you're satisfied with your progress, go on to the next exercise.

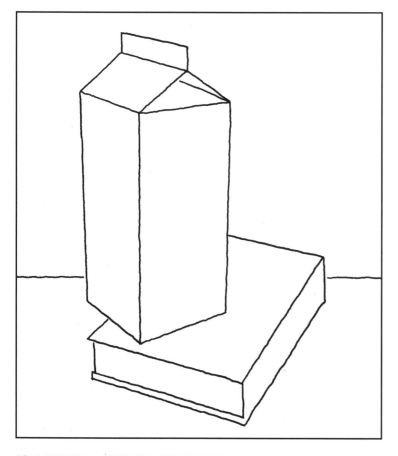

Exercise 4-2

Add another object and draw both items.

Practice drawing the two objects arranged at least one other way.

When you're satisfied with your progress, go on to the next exercise.

Exercise 4-3

Add yet another object to the group of items in front of you. Draw the collection of objects.

Practice drawing the group of objects arranged at least one other way.

When you're satisfied with your progress, go on to the next exercise.

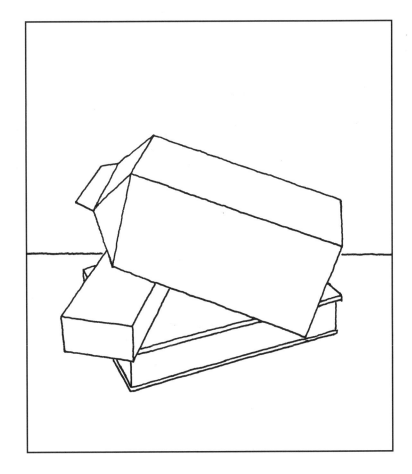

Exercise 4-4

Now draw more than three objects.

Again, continue practicing by drawing your collection in different arrangements.

> ### Drawing a Box from Observation
> Many objects – especially manufactured ones such as television sets – are box-like in shape or could fit well inside a box. To help you learn to draw such objects, choose a variety of boxes and practice drawing them at many different angles.

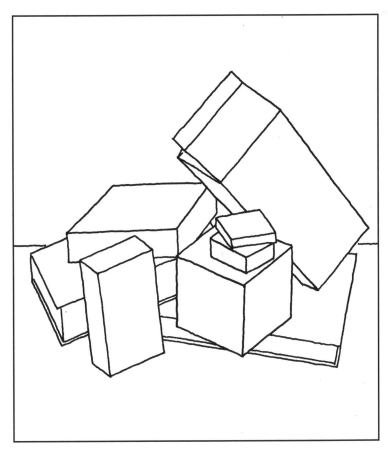

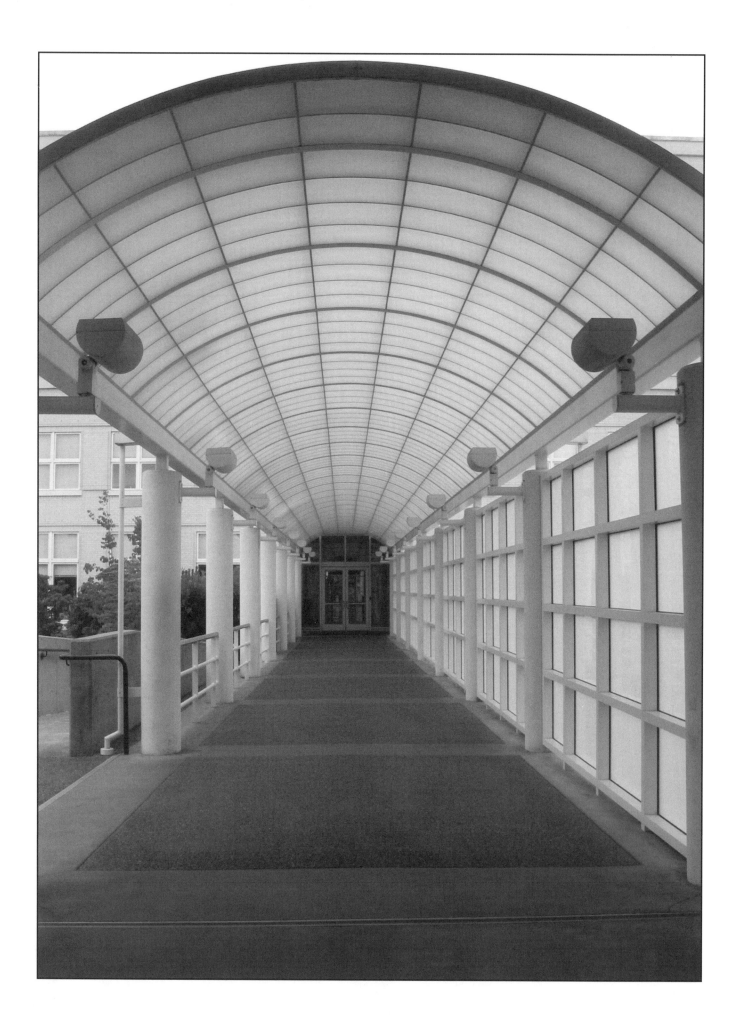

5
Mastering Circular Lines

When once asked by a potential customer for a sample painting, so the legend goes, Leonardo da Vinci proved his skill by instead drawing a perfect circle. Circles are continuous arcs, and arcs are parts of circles. In this chapter, you'll learn to draw arcs with confidence and can then practice drawing straight lines and arcs together.

Start with another experiment, using your real drinking glass again. Hold it in front of the opposite page, and position it so that you see its opening as a full circle. Then match part of this circle with one of the arcs at the top of the walkway in the photograph. Now you're ready to begin learning more about arcs.

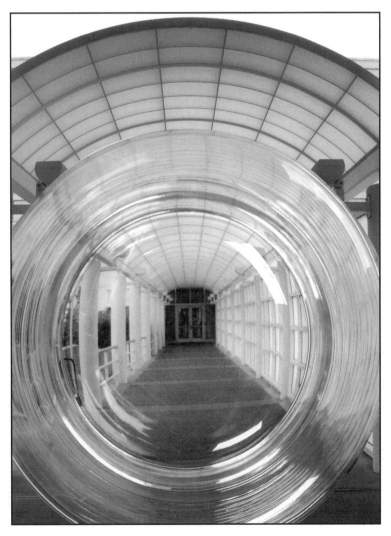

Seeing Arcs as Parts of Glasses

To help you observe, visualize, and draw arcs, **first** imagine a clear drinking glass suspended with the opening facing you so that you see a full circle. **Next**, on your subject and then on your paper, match part of the glass with the arc that you want to draw.

If the arc has a narrower curve, your glass needs to be smaller.

If the arc has a wider curve, your glass needs to be larger.

Visualizing a Glass from the Top

Make your imaginary glass look like a whole glass...

...or just the opening of a glass.

Keeping the glass's opening in your mind will help you to observe, visualize, and draw arcs.

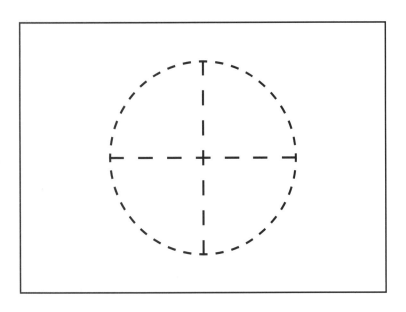

A Special Way to Draw Circles

To practice drawing circles, **first** visualize crossed perpendicular guidelines of equal length inside a circle on your paper. If you need to visualize a physical object to help you draw circles, imagine the opening of a drinking glass.

> **Why Draw Circles?**
> As you practice drawing circles, it becomes easier for you to draw arcs, and when you can draw arcs accurately, it will be easier for you to draw any curved line.

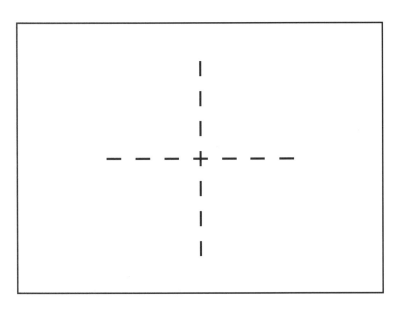

Next visualize just the guidelines. Make sure that they're equal.

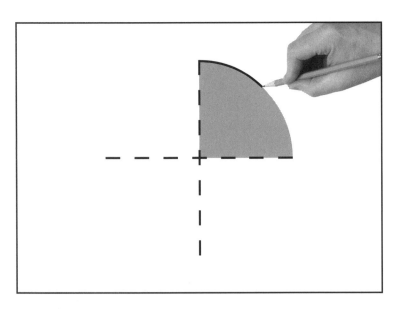

Then draw an arc from guideline to guideline to create the first quarter of the circle. As you draw it, visualize the one-quarter pie shape that the arc will make against the guidelines.

Next visualize a full circle around the crossed perpendicular guidelines as you draw another quarter of the circle.

For greater accuracy, envision a diagonal guideline connected to the other guidelines while drawing this and each remaining quarter of the circle (as shown to the right). Picture this guideline to help you focus on the ends of each quarter-circle as you draw it.

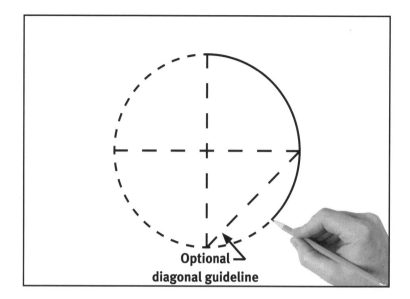

Optional diagonal guideline

Then draw the next quarter of the circle while still visualizing a full circle and the guidelines.

TIP: Visualize a string tied to the tip of your pen or pencil and tacked to your paper in the center of the guidelines. This visualization makes you more aware of the constantly curving path that your hand must take to draw a circle.

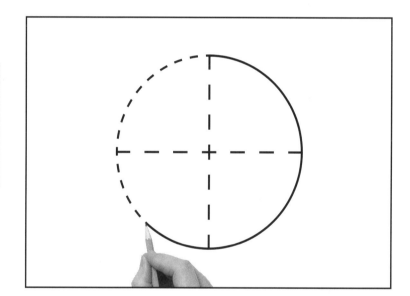

Next, complete the circle in the same way.

Practice drawing your circles clockwise, counterclockwise, and in various sizes.

Evaluating Your Circles

To evaluate your practice circles, look at their average circularity. You probably won't be able to draw perfect circles without a compass or a template.

Being able to draw **nearly** perfect circles will help you to draw whatever type of circle or arc that you're likely to need.

Even though these circles (to the left) are smoother than the circles just above, their shapes are less accurately drawn.

You can also evaluate your circles by slowly rotating them.

Try it now by rotating this circle and observing its irregularities.

Now try rotating this circle. Even though it's not drawn as smoothly as the one on the previous page, it's closer to being a true circle.

Here's another way to evaluate your circles. Divide each circle with crossed perpendicular straight lines, and compare the four sections to each other.

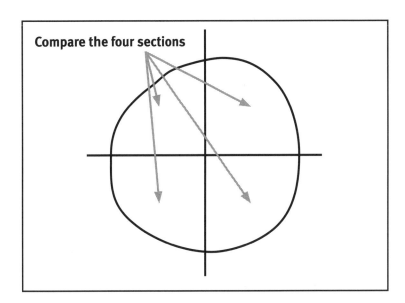

Compare the four sections

Alternately, you could draw a square around each circle and then compare the four space shapes around each circle to each other.

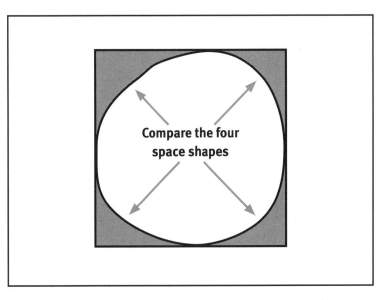

Compare the four space shapes

Exercise 5-1

To test and improve your ability to draw arcs and then straight lines and arcs together, draw real objects. Collect some items with straight lines and some with arcs. You're already familiar with objects that have straight lines. Objects with continuous arcs include billiard balls, marbles, beach balls, and ping-pong balls. Don't choose items that are circular and flat such as coins, because they'll appear as ellipses from most angles.

Place one of the round objects in front of you, and tape your paper to your drawing surface. Draw the round object with an emphasis on drawing it against a horizon background line. If a convenient background line isn't available, create one with a string or piece of tape.

When you're satisfied with your progress, go on to the next exercise.

Exercise 5-2

Add an object with straight lines. Draw the two items with an emphasis on drawing straight lines and arcs.

Practice drawing the two objects arranged at least one other way.

When you're satisfied with your progress, go on to the next exercise.

Exercise 5-3

Add another object to the group of items in front of you. Draw the collection of objects.

Practice drawing the group of objects arranged at least one other way.

When you're satisfied with your progress, go on to the next exercise.

Exercise 5-4

Now draw more than three objects.

Again, practice drawing your collection in different arrangements.

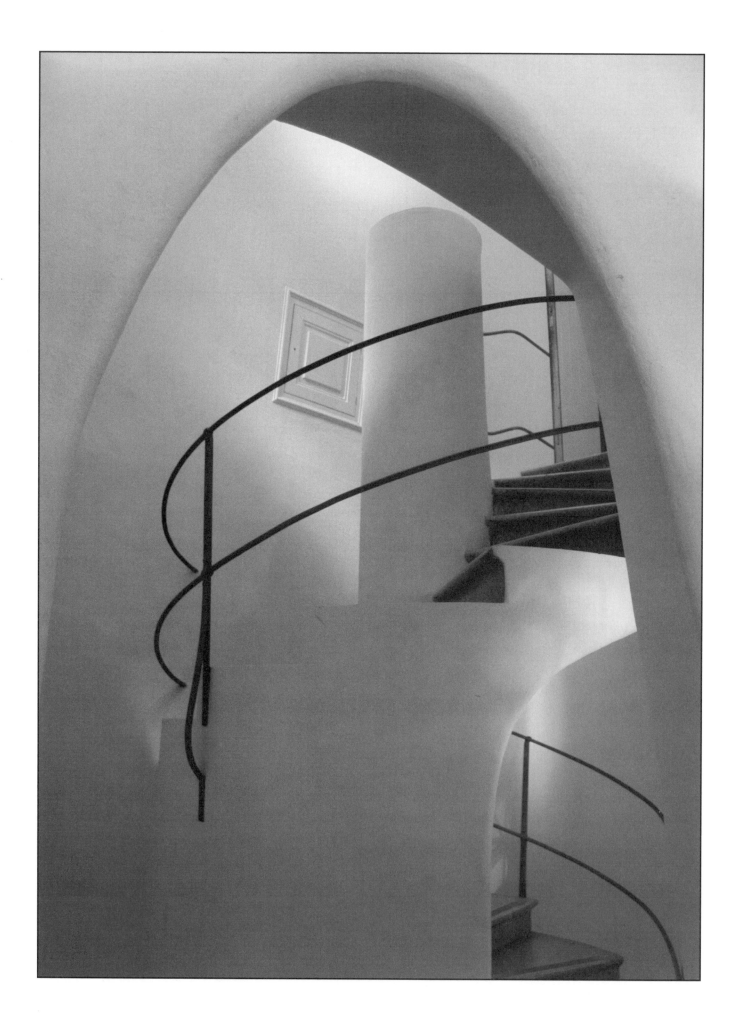

6
Mastering Elliptic Lines

If you look at circles from an angle, they become ellipses, and if you look at an arc from an angle, it becomes part of an ellipse. In this chapter, you'll learn to draw elliptic lines with confidence and practice drawing all the building-block lines together.

Before going to the next page, do one more experiment with your drinking glass. This time, as you hold it in front of the opposite page, position it so that you see its opening from an angle. Match part of its opening with one of the elliptic lines formed by the staircase railings in the photograph. Now you're ready to begin learning more about elliptic lines.

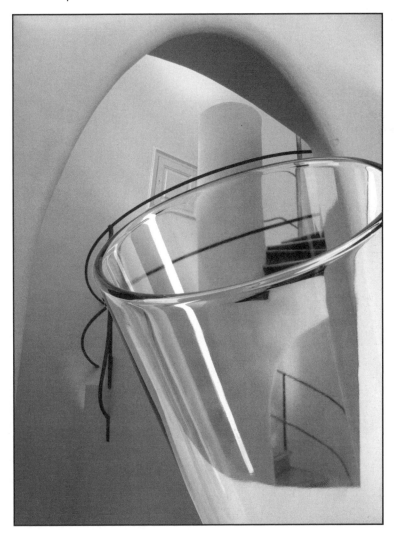

Seeing Elliptic Lines as Parts of Glasses

To help you observe, visualize, and draw elliptic lines, **first** imagine a clear drinking glass with its opening facing you at an angle so that you see an ellipse. **Next**, on your subject and then on your paper, match part of the glass with the elliptic line that you want to draw.

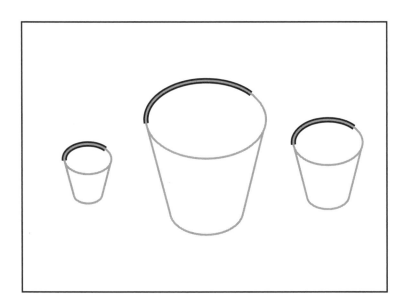

For different sizes of elliptic lines, imagine your glass as smaller or larger.

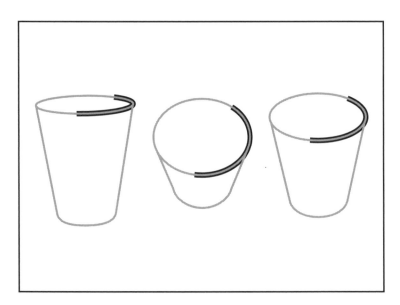

To draw different shapes of elliptic lines, imagine (or move) your glass so that the opening looks rounder or flatter.

Seeing a Glass in Perspective

You can draw glasses and many other round objects more accurately by remembering the following fact: If you hold a clear glass upright at eye level in front of you, its rim appears more circular the farther you raise or lower the glass from its original position. (If you experiment with a clear glass, as you raise it but keep it level, you'll see the rim through the sides of the glass.)

Visualizing a Tilted Glass

Make your imaginary glass look like a whole glass...

...or just the opening of a glass.

As long as you can see the opening in your mind, it can help you observe, visualize, and draw elliptic lines.

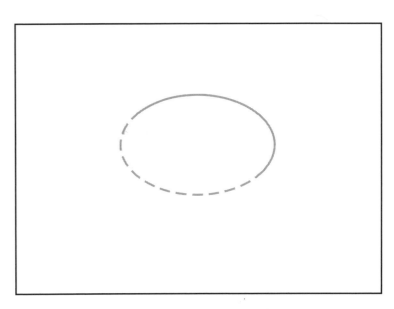

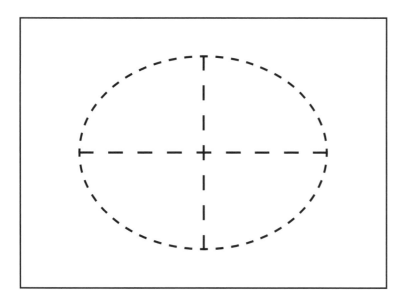

A Special Way to Draw Ellipses

To practice drawing ellipses, **first**, on your paper, visualize crossed perpendicular guidelines inside an ellipse. If it helps to visualize a physical object, imagine the opening of a tilted drinking glass.

> **Why Draw Ellipses?**
> If you practice drawing ellipses, it becomes easier for you to draw elliptic lines. And when you're able to draw elliptic lines accurately, it will be easier for you to draw any curved line.

Next visualize just the guidelines.

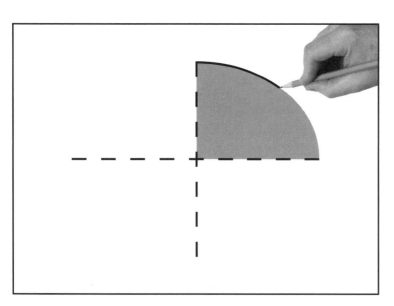

Then draw an elliptic line from guideline to guideline to create the first quarter of the ellipse. As you draw it, visualize the shape that the elliptic line will make against the guidelines.

Next visualize a full ellipse around the crossed perpendicular guidelines as you draw another quarter of an ellipse.

For greater accuracy, envision a diagonal guideline connected to the other guidelines while drawing this and each remaining quarter of the ellipse (see the image to the right). Picture this guideline to help you focus on the ends of each quarter-ellipse as you draw it.

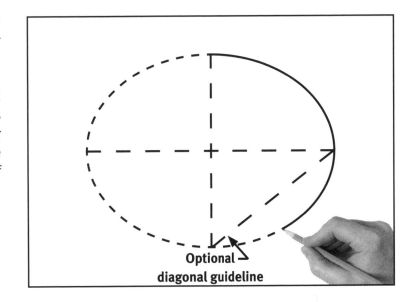

Optional → diagonal guideline

Then draw the next quarter of the ellipse while still visualizing the full ellipse and the guidelines.

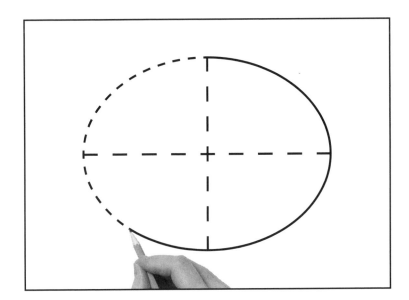

Next, complete the ellipse in the same way.

Practice drawing your ellipses clockwise, counterclockwise, in various sizes, and at different angles.

TIP: To practice drawing straight lines, half-circles, and halves of ellipses together, draw – from your imagination – side views of two-piece, hollow plastic eggs. Draw a half-circle and half of an ellipse to create the two parts of an egg shape. Draw a straight line between the parts to create the seam where they join.

Evaluating Your Ellipses

To evaluate your ellipses, notice how closely they resemble true ellipses. Remember that perfect ellipses are difficult to draw without a template.

If you can draw **nearly** perfect ellipses, you can draw whatever type of ellipse or elliptic line you're likely to need.

Even though these ellipses (to the left) are smoother than those above, their shapes are less accurately drawn.

A circle seen from an angle looks like an ellipse. Likewise, an ellipse seen from an angle can look like a circle. You can also evaluate your ellipses by looking at them from their long ends to see how closely they resemble circles.

Test this concept by looking at this ellipse from the far left edge of the book. Hold the book page flat, just below eye level, and adjust the angle of the page until the ellipse becomes a circle.

When you look at this ellipse at a steep enough angle from the far-right edge of the book page, it becomes an inaccurately drawn circle.

Here's another way to evaluate your ellipses. Divide each ellipse with crossed perpendicular straight lines, and compare the four sections to each other.

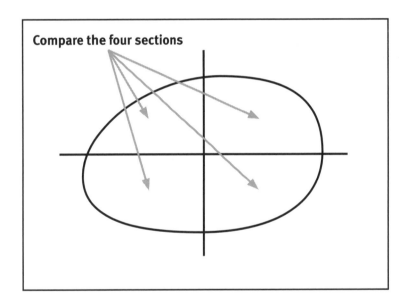

Compare the four sections

Alternately, you could draw a rectangle around each ellipse and then compare the four space shapes around each ellipse to each other.

Compare the four space shapes

Exercise 6-1

To test and improve your ability to draw elliptic lines alone and then in combination with straight lines and arcs, draw real objects. Collect some items with straight lines, some spherical items with arcs, and some round, flat items that you can position to appear elliptic. You're already familiar with straight lines and arcs. Objects that can appear elliptic include coins, bowls, plates, and drinking glasses.

Place one of the round, flat objects in front of you so that it appears elliptic. Tape your paper to your drawing surface. Draw the object with an emphasis on its elliptic lines.

When you're satisfied with your progress, go on to the next exercise.

Exercise 6-2

Now add an object with straight lines. Draw the two items with an emphasis on drawing straight lines and elliptic lines.

Practice drawing the two objects arranged at least one other way.

When you're satisfied with your progress, go on to the next exercise.

Exercise 6-3

Add an object made with arcs to the group of items. Draw the collection of objects with an emphasis on drawing straight lines, arcs, and elliptic lines.

Practice drawing the group of objects arranged at least one other way.

When you're satisfied with your progress, go on to the next exercise.

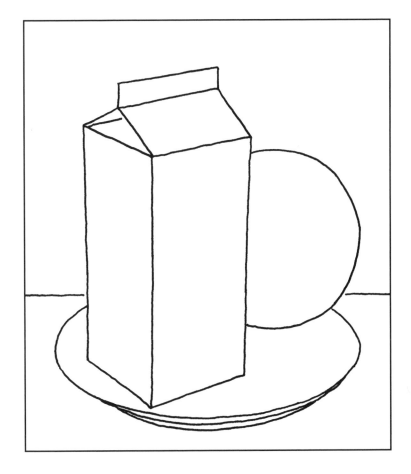

Exercise 6-4

Now draw more than three objects.

Again, practice drawing your collection in a variety of different arrangements.

Drawing a Glass from Observation

Many objects – especially manufactured ones such as flowerpots – are cylindrical or could fit well inside a cylinder. To help you draw those objects, choose a cylinder-shaped glass, and practice drawing it placed in various positions: upright, tilted, and on its side.

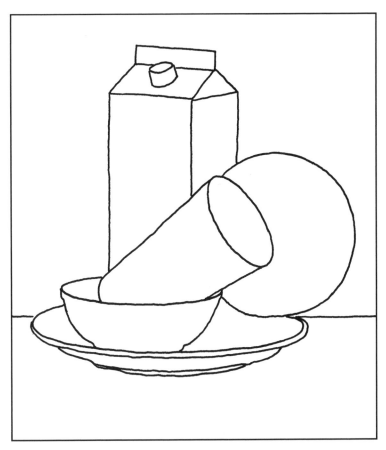

"Art is filling space in a beautiful way."

– Georgia O'Keefe

Part Three
Expanding Your Drawing Skills

In part 3, you'll learn to see with an eye for artistic composition and to view all lines as variations of the building-block lines.

Chapter 7 covers important basic principles of drawing composition. Chapter 8 helps you apply those principles and build on what you've learned so far.

10 Ways to Draw Better

✏ Teach someone else how to draw.

✏ Visit art galleries and museums.

✏ Study objects up close.

✏ Draw one composition many times.

✏ Draw the same subject from many angles.

✏ Practice drawing regularly instead of in spurts.

✏ Spend time learning about your drawing subject.

✏ Frame and hang one or more of your drawings.

✏ Draw very slowly once in a while.

✏ Draw with a group.

7
An Introduction to Drawing Composition

Composing a drawing involves arranging lines and shapes to take viewers on a visual journey. This chapter shows you how to use principles of design to affect the way that the viewer's eyes move on that journey. It also helps you create your own interesting and appealing arrangements of objects to draw.

You can learn much about composition by analyzing visual compositions of all kinds. Notice how an effective composition takes advantage of the concepts you're studying. To draw objects more easily, observe the visual connections between them and how they fit inside your drawing paper's format.

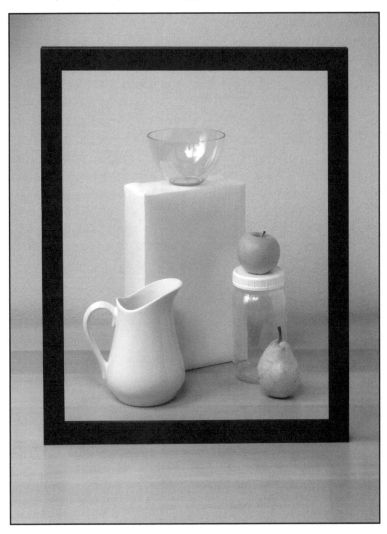

The Rule of Thirds

The Rule of Thirds can be applied to any artistic composition. It suggests that you mentally divide your picture with lines into thirds, vertically and horizontally, and then place important parts of your subject near these lines, especially where they intersect.

Following the Rule of Thirds helps you create better compositions. A center-of-interest object in the middle of a drawing can look predictable and bring the viewer's scanning eyes to a halt.

This drawing (to the left) demonstrates the use of the Rule of Thirds. Notice how the background space is broken up and how your eyes move around the objects.

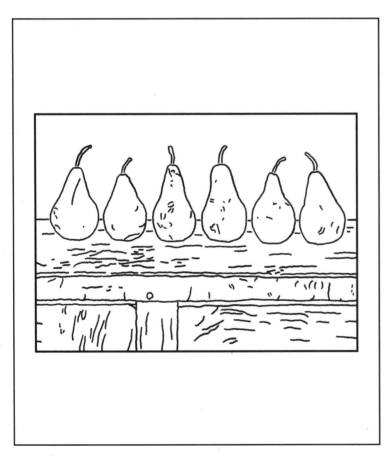

Humans search for a sense of order or pattern. When they see elements suggesting a pattern, they look for other elements to support that pattern. When you first viewed the composition to the left, you probably moved your eyes along the entire row of pears to observe their pattern.

Notice that the table edge divides the picture across its bottom third. Look for other ways that objects divide this composition.

The Rule of Thirds helps you create highly visible patterns in your drawings. Without such patterns, viewers might see a composition as unsatisfying, chaotic, or simply boring.

A composition can appear too busy if viewers have no place to rest their eyes. One way to create a visual "resting spot" is to make one or more intersections of the Rule of Thirds' dividing lines noticeably less busy.

Look at this drawing, and imagine that a sunflower sticks out of the boot to the far right. Would the sunflower make the drawing too busy? If so, which objects would you move or remove to make the composition more appealing?

> **TIP:** Composition is an art, not a science. Use the Rule of Thirds and other concepts in this chapter as guides. If they don't fit your particular purpose, adjust them or ignore them. With more experience, you'll learn to trust your artistic instincts and to rely less upon artistic "rules."

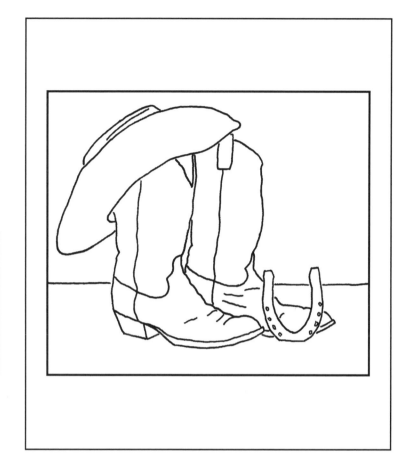

Line Direction

Pay attention to line direction when you arrange objects to draw. Like directional arrows, lines direct the eye's journey. Horizontal and vertical lines align with, and are strengthened by, rectangular picture formats. Diagonal lines contrast with and therefore stand out in the rectangular format.

Notice how the horizon line grounds this image and directs the eye, and observe the interplay between the diagonal, horizontal, and vertical elements.

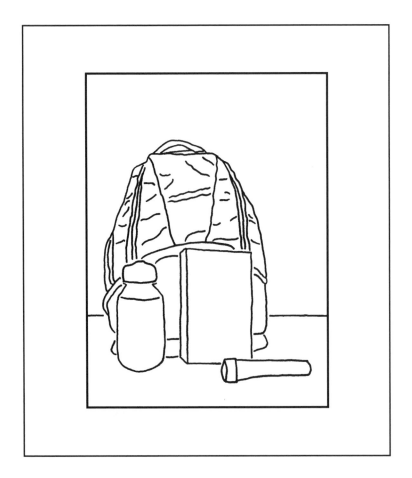

Line Complexity

An object will tend to stand out if it's different from surrounding objects in terms of its complexity.

In this composition, the center of interest is the backpack. It looks more complex than the other objects because its lines are more complex, and because it's been drawn in greater detail. (It stands out, too, because of its size in relation to the other objects.)

The technique works both ways. You can create a center of interest with an object that's simpler, or one that you've drawn to look simpler, than the surrounding objects.

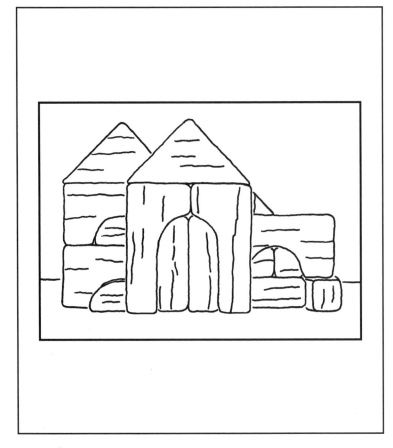

Line Rhythm

Create rhythm or patterns in your compositions with repetition. Add interest to line rhythms through variations in line direction, length, shape, and spacing.

In this composition, because the lines of the wood grain on the original subject were so densely packed, the grain is suggested only with parts of lines on each block. The lines echo each other, and their lengths correspond to the shapes of the blocks.

Implied Lines

Implied lines guide your eyes around a picture and stimulate the imagination. As mentioned on page 26, an implied straight line exists between any observed pair of points. The "psychic" line is a special type of implied line. It begins at the eyes of a subject and extends to the object of the subject's gaze.

In this image, notice how an implied line connects the repeating shape of the curving chair backs to create an S shape.

Notice also how some parts of the chairs aren't visible. Good composition invites viewers to use their imaginations to create unseen elements such as the rest of the chair backs.

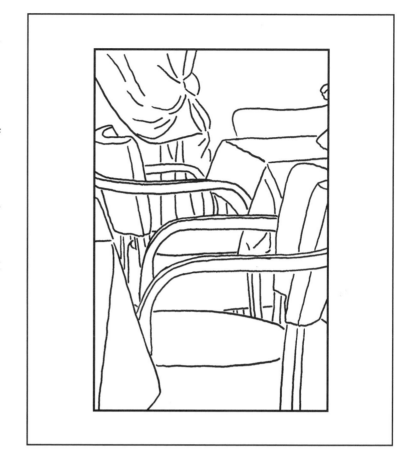

When you look at a rectangular picture, each pair of diagonal corners creates an implied diagonal line between them. Objects placed along these crisscrossing implied lines appear to be supported. These objects are emphasized and appear more integrated with the entire picture. When viewers notice one or more objects supported by an implied diagonal line, they tend to also scan across the area of the other implied diagonal line.

The arm and hand to the left side of this picture are located along an implied diagonal line.

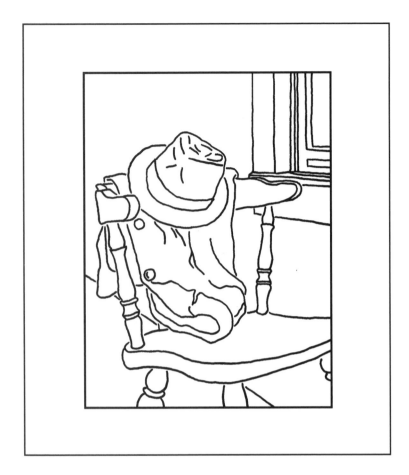

Overlapping and Cropping

The main purpose of overlapping and cropping is to direct the viewer to the most important part of the subject. When you decide what to overlap or crop, be sure to create "eye pathways" and then include less-detailed or open areas where the eyes can rest.

Group objects to make interesting solid shapes and space shapes. As you compose with shapes, always consider the whole picture. In the image to the left, notice how the window, cropped by two borders of the picture, makes a small rectangular shape. The borders cut the window off from view and tie it into the picture.

Overlapping helps to create the illusion of depth. Strengthen this effect by drawing clearly visible breaks in lines of objects where they are overlapped. Notice how breaks in some of the lines in the hat suggest overlapping and add dimension.

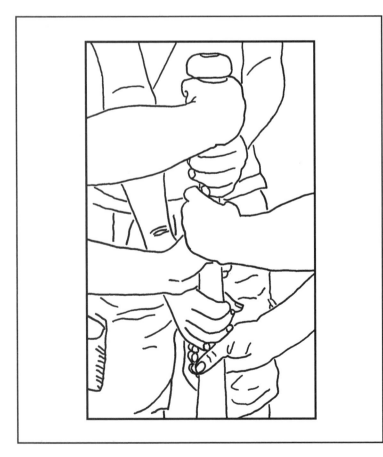

Shape Rhythm

Like line rhythms, shape rhythms are achieved through repetition. Interesting shape rhythms can be achieved through variations in the size, direction, and spacing of the shapes.

In the composition to the left, the viewer's eyes can take many paths. For example, one path follows the hands stacked vertically along the bat. Another path circles around the space shapes formed by the arms and hands. Background shapes fill in the space shapes.

Implied Shapes

When you overlap and crop objects, you create implied shapes that the viewers visualize. They mentally complete overlapped objects, and they mentally fill in cropped shapes that run off the picture's edge. Notice the shapes implied in the composition to the right by the overlapped and cropped objects.

Implied shapes are also created in this picture by implied lines. The overlapping pillows and blanket have missing boundaries that suggest lines. These lines in turn help create implied shapes. The missing boundaries also provide eye pathways that tie the pillows and blanket together as a unit.

There's an implied triangular shape between the pillows on the couch. It points to an obvious place to sit, as if to say, "Here's a cozy spot. Make yourself at home."

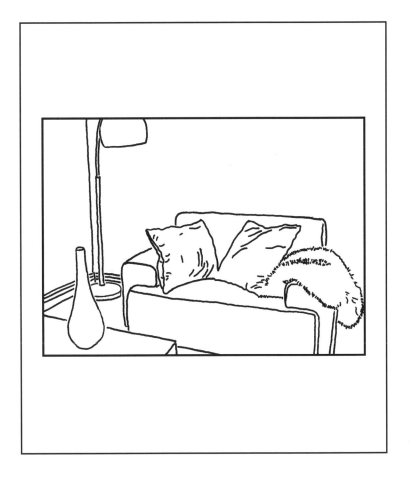

Dominant Shapes

You can bring unity to a drawing and give it a more interesting appearance by making one shape larger than the rest. The large shape helps tie the other shapes into the picture. A unified composition is usually more interesting because it presents a sense of order.

In this image, notice how the washing machine dominates the composition. In the composition just above, the space shape created by the two walls dominated.

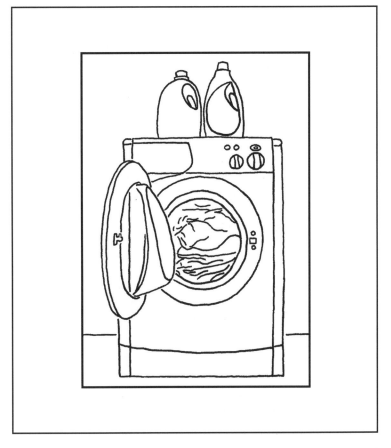

8
Beyond the Building-Block Lines

In part 2, you learned how to draw pictures with the building-block lines. In this chapter, you'll begin to use those lines as unique drawing tools to help you create pictures with all types of lines. You'll also apply the principles of composition.

What would you most like to draw? To motivate yourself, pick a subject that interests you or that you'd like to know more about. For example, if you like to cook, draw one of your favorite ingredients. To get more enjoyment from your drawings, display them where you'll see them often. You might be surprised at how much you will enjoy viewing your own artwork.

Seeing Lines as Variations of the Building-Block Lines

To help you observe, visualize, and draw any line, compare the straightest parts to a straight line, and compare the curved parts to an arc or an elliptic line.

In this example, the line has curved parts and irregular parts. Compare one of the curved parts to an arc.

Compare the line to the left to a straight line. Notice how a straight line is similar and how it's different.

> **TIP:** If you recognize a line as a straight line, elliptic line, or arc, draw it with the skills you already have.

Compare this line to an elliptic line.

> **Why This Technique Works**
> Observing lines as variations of the building-block lines allows you to relate complex lines to simple lines with which you're already familiar.

Deciding How to Analyze Lines

When you analyze lines, you might not be sure which parts are straightest and which are curved, or you might wonder whether to compare a curved part to an arc or to an elliptic line. There's not always a single right choice.

You could compare the line to the right to a straight line or to a wide arc.

You could compare this line to an arc or to an elliptic line.

Likewise, you could compare this line to an arc or to an elliptic line.

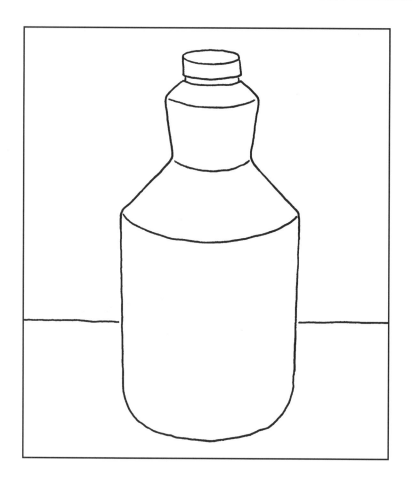

Exercise 8-1

To test and improve your ability to draw all types of lines, draw real objects. Gather some items that you would enjoy drawing, or create a theme by picking one item and then finding other things to go with it.

Place one of the objects in front of you, and tape your paper to your drawing surface. Draw the object. If you picked a juice bottle, your drawing might look like the one shown to the left.

When you're satisfied with your progress, go on to the next exercise.

Exercise 8-2

Now add an object (such as a banana). As you decide how to position the objects in this and the next two exercises, apply principles of composition. Draw the two items.

Practice drawing the two objects arranged at least one other way.

When you're satisfied with your progress, go on to the next exercise.

Exercise 8-3

Add yet another object to the group, and then draw the collection of objects.

Practice drawing the group of objects arranged at least one other way.

When you're satisfied with your progress, go on to the next exercise.

Exercise 8-4

Now draw more than three objects.

As before, practice drawing your collection in different arrangements. When you're satisfied with your progress, congratulate yourself for your persistent effort.

To maintain or surpass your current skill level, keep drawing regularly. This might be a good time to explore the books on the Recommended Reading page, to sign up for a drawing class, or to draw with other people.

If you've practiced the exercises in this book diligently, you now have a foundation for more advanced artistic pursuits. You've developed an artist's eye for seeing shapes. You've gained a working sense of composition. And best of all, you've mastered the most basic component of drawing: the line.

Glossary

Alignment: The act of placing parts in their correct positions relative to each other.

Arc: Any part of a circle.

Circle: A continuous curved line with all points at the same distance from a common center.

Circular line: See **arc** and **circle.**

Combination shape: A shape formed by more than one object.

Cornerstone points: Drawn points used in pairs to assist with placement of other points.

Cornerstone shape: A section of a shape drawn first to serve as a point of reference for drawing the rest of the shape in proportion.

Cropping: Cutting part of a subject off from the observer's view at the edge of a composition.

Diagonal: Slanting or tilting across.

Ellipse: A circle seen from an angle.

Elliptic line: Any part of an ellipse. An arc seen from an angle.

Forms: Shapes with inner contour lines that create the perception of depth.

Guidelines: Visualized or drawn straight lines used to show how parts of a subject align with each other.

Horizon: The line where the ocean or landscape meets the sky.

Horizontal: Flat or parallel to the horizon.

Implied line: An imaginary straight line between any two observed points. An implied line can also connect the ends of any line that isn't perfectly straight.

Implied shapes: Shapes visible only in the viewer's mind, that are suggested or implied by overlapping, cropping, or implied lines.

Line: A narrow mark or expanse connecting two points.

Parallel: Objects that are side by side with equal distance between them at all points.

Perpendicular: Objects located at right angles to each other. If a line is exactly horizontal, a line perpendicular to it will be exactly vertical.

Perspective: The art and science of portraying objects on a two-dimensional surface so that they present the illusion of depth.

Proportion: The comparative relationship of different parts or wholes with regard to any measurable characteristic.

Rectangle: A shape having four sides with all four sides intersecting at right angles to each other.

Redrawing: Adjusting lines while drawing a picture.

Rule of Thirds: A guideline for dividing a picture's format into thirds that serves as a basis for composing.

Scale: The relative size of an object, or the ratio of one object's size to another's.

Shapes: Areas enclosed by definite outlines.

Sighting: Using a straight object, such as a pencil, to measure angles and lengths.

Slope: The amount or degree that a line or object slants or tilts compared to a horizontal straight line.

Space shapes: Shapes created by spaces within, around, and between objects.

Square: A rectangle with sides of equal length and intersecting at right angles to each other.

Straight line: A continuous line without curves.

Two-sided triangle: A triangle formed by two lines joined at an angle, while the third side is formed by an implied or imagined line between the open ends of the two joined lines.

Vertical: Upright or perpendicular to the horizon.

Recommended Reading

The Art of Teaching Art by Deborah A. Rockman (NY: Oxford University Press, Inc., 2000). Valuable instruction for students, too. Useful as a detailed overview.

Drawing by Philip Rawson (PA: University of Pennsylvania Press, 1987). A wide-ranging discussion of drawing techniques through the ages. Includes fascinating information about composition as it relates specifically to drawing. A worthwhile book demanding intense study.

Drawing from Observation by Brian Curtis (NY: McGraw-Hill, 2002). Especially useful for its suggestions on how to position and use your body while drawing.

Drawing Lessons from the Great Masters by Robert Beverly Hale (NY: Watson-Guptill Publications, 1989). Inspiring descriptions with illustrations of how great masters from the past drew people. Includes plenty of suggestions that can be applied to drawing other subjects as well.

Keys to Drawing by Bert Dodson (OH: North Light Books, 1985). A good general drawing book.

Learn Art in One Year by Robert Girard (NY: Avenel Books, 1968). Covers 52 topics with a few pages devoted to each. Another good general drawing book.

The Simple Secret to Better Painting by Greg Albert (OH: North Light Books, 2003). Based on an easy-to-remember rule.

Strengthen Your Paintings with Dynamic Composition by Frank Webb (OH: North Light Books, 1994). An entertaining book on composition. Full of informative examples.

Thinking with a Pencil by Henning Nelms (CA: Ten Speed Press, 1981). Recommended for those also interested in the more practical applications of drawing.

Acknowledgments

With heartfelt appreciation, I acknowledge these people for their contributions:

Bob Gill for designing and illustrating the cover;

Rob Ottley for designing the layout;

Jim Alan, Lori Callister, Robert Hartwell Fiske, Colleen Johnson, Greg LeFever, Tobi Kibel Piatek, Denise Seith, Lori Stephens, and Victoria Tarrani for editing the text;

April Silver for creating the index;

Richard Bulman, Loren Fraize, Betty Johnson, D. W. Miller, Michael Southern, and Jeré Willett for answering questions about drawing;

Mary Ann Carter, Marshall Cook, Bob Goodman, Dawn Grillo, Suzanne Hansen, Bill Harvey, Dawn Hawthorne, John Hedtke, John Kremer, Antoinette Kuritz, Jared Kuritz, Judy McFarlane, David McKay, George Niver, Mark Ortman, Nancy Osterhout, Dan Poynter, Earl Rogers, Kathryn Rutledge, Peter Sanchez, Kelly Sandstrom, Phil Way, and Deniece Won for their advice and encouragement;

Kimberlie Jacobson, my CPA, who can work and listen at the same time;

Joseph Mathis and John McNally for taking photographs used throughout the book;

Gettyimages.com and Istockphoto.com for granting me license to use their photographs;

Pushdot Studios for modifying photographs;

and the authors of the books on the Recommended Reading page.

Index

M

mistakes, 18

O

outlines, 14–15, 32, 41, 49
overlapping, 90

P

paper, 7
parallel lines, 57
pencils, 7 (see also sighting objects)
points of reference
 endpoints and, 28
 guidelines and, 30–33
 main shape as, 47, 49
 placement of objects and, 40–41
 rectangles as, 26–28, 37
 shapes as, 37, 42–43, 47, 49
 triangles as, 28, 34–37
proportion, 16–17, 42–43

R

rectangles
 placement of objects and, 40–41, 44
 points of reference and, 26–28, 37
redrawing, 18
reference points (see points of reference)
roofs, lines as, 56
Rule of Thirds, 86–87

S

scale, 19
shapes
 cornerstone points and, 44–49
 points of reference and, 37, 42–43, 47, 49
 proportions of, 16–17, 42–43
 remembering, 19
 seeing, 12–15, 19
shapes, cornerstone, 42–43
shapes, implied, 37, 91
shapes, solid, 12–13 (see also subjects)
shapes, space, 12–13, 33, 40–41, 69, 79
sighting objects
 as guidelines, 30–31
 measurement of angles and, 27, 29, 40
 placement of objects and, 40
 proportion and, 16
solid shapes (see shapes, solid)
space shapes (see shapes, space)

S (continued)

squares, 58–59 (see also lines, straight)
stepping back, 14
straight lines (see lines, straight)
subjects, 40–41, 44–45, 48
symmetry, 32

T

triangles
 cornerstone points and, 46–48
 guidelines and, 35–36
 points of reference and, 28, 34–37
 visualization of, 34, 37

V

vertical reference lines, 24–27 (see also guidelines)
visual resting spot, 87

Ordering Information

Join those who use *The Drawing Breakthrough Book* to help make drawing a part of their daily lives. It is available in local art supply stores and bookstores. It's also available directly from the publisher for $15.95.

☎ **Telephone orders:** 503-648-9905

[WEB] **Web orders:** www.Draw3Lines.com

@ **Email orders:** orders@Draw3Lines.com

✉ **Postal orders:** Send a check or money order to

Draw 3 Lines Publishing
P.O. Box 1522
Hillsboro, OR 97123-3954

Shipping: $4.50 for first book and $2.00 for each additional copy (we ship by Priority Mail).

For quantity discounts, call 503-648-9905.

Creating a shorter path to artistic excellence
www.Draw3Lines.com